LINE BY LINE

LINE BY LINE

The drawings of Henri Cartier-Bresson

Foreword by John Russell

Introduction by Jean Clair

with 65 reproductions, 9 in color and 56 in duotone

Thames and Hudson

This book contains reproductions of drawings and related works from
the years 1966 to 1988

Designed by Robert Delpire

First published in the United States in 1989 by
Thames and Hudson Inc., 500 Fifth Avenue,
New York, New York 10110

Library of Congress Catalog Card Number 88-50235

Printed in Switzerland by Imprimerie Jean Genoud

Contents

To Tériade

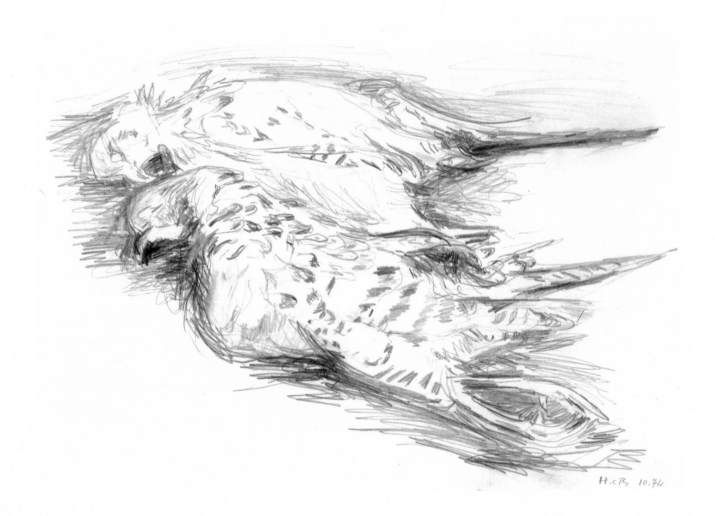

H.cB 10.74

The Artist as Hunter

He tells me that he likes to think of his camera as a gun. When a young man, he both painted and hunted and, given great intuition, a form of Zen, his pheasant came to meet his shot. But now he approaches the dead brace of birds – and he asks: 'What is their existence?'

Certainly the camera shots of Henri, always the opposite of death, were rather the epitome of what André Breton called 'convulsive beauty'. Indeed Breton, in *L'Amour Fou,* used one of Henri's photographs to illustrate his theory of 'le hasard objectif' – convulsive, frozen and eternal. But today Henri wants that convulsed stopped motion to move just a little, to divulge its new reality. And his questioning line trembles just before and after.

It was many years ago that his early photographs were introduced in my gallery in New York, in 1932, a discovery incredible at that time. Having stopped reality with some of the most extraordinary photography ever, Henri is now questioning the fallen bird. Was it alive a moment ago, and will it be again?

Another might use a movie camera to find easier answers, a loop that scans back and forth over the moment of truth. He chooses instead to use pen or pencil for his inquisitive line. One is reminded of Giacometti whose solid sculpture suddenly became too sure for his doubts, and who wove a linear web to entrap his prey, his sculpture becoming smaller as his drawings filled the room.

Henri Cartier-Bresson does not adopt an unfamiliar medium. He was schooled in painting since an early age. Another facet of our elusive friend, these drawings are a new discovery! For him and for us.

Julian Levy
Paris, December 1974

Foreword by John Russell

There is a drawing that I look at every day. It is of a prosperous intersection in Paris, not far from the Arc de Triomphe, and it was done in 1981. Though made with graphite on cream-coloured paper, the image has overtones – like Paris itself in deep winter – of granite and old silver.

Its basic component is a brisk, deft, highly energized back and forth of pencilled strokes. Sometimes those strokes are bunched and clustered, as if the pencil were acting as a special investigator. Sometimes they whisk lightly across the paper, as if carried this way and that by ferocious winter winds. (The wind in that part of Paris is funnelled through the long, straight streets that were put on the drawing-board by Baron Haussmann during the reign of Napoleon III.) Looking at the intersection of these two kinds of stroke, we sense that the person who held the pencil is both ardent and adroit, headstrong and yet true to his every perception.

The subject of this drawing is a relatively anonymous and unsung part of Paris. (We cannot imagine Guillaume Apollinaire writing about the Place des Ternes in the terms that he used of the Pont Mirabeau.) Nor is the season seductive. No tree is in leaf. Every man, and every woman, stays home behind quilted doors and windows closed and bolted. We even wonder if the cars parked in the foreground will ever again respond to the starting button. Meanwhile, they lie there like so many motorized sides of beef, fresh from the slaughter-house.

But then everything in sight is immobilized and quite possibly out of commission. Weeks have passed since the last billposter went to work on the onion-domed column on the far right that normally lists concerts, theatres and mortally dull lectures. This is a straight-faced, shut-faced, frozen-faced Paris.

When I first saw drawings of Paris from this same hand, in the Carlton Gallery in New York in 1975, I was reminded for a moment of Alberto Giacometti's posthumous book of lithographs, *Paris Sans Fin,* published by Tériade. But Giacometti's vision of Paris has to do with the poetics of impossibility. In the drawing that I look at, there is none of that. Raid and reconnaissance do not fail of their effect. Positions – street corners, let us say, and points of vantage, and the strange, withered little park in the foreground – are taken and consolidated.

It is as if the whole city were in a state of mineral flux and mutation, with the apartment house in the middle ground looking like the prow of an ocean liner that has pushed its way several hundred miles inland. And yet Paris also asserts itself in terms of stability and decorum, stasis and deserted pavement, to which nature is at most incidental.

Even so, the role of nature in this drawing is not subordinate. Those trees speak for an alternative order of things, in which from inch to inch, and from mark to mark, contradictory extremes coexist in equilibrium. Their every spiky branch is alive and alert, feeling its way towards a distant April.

In 1975 I knew nothing of the activity of Henri Cartier-Bresson as a painter and draughtsman. Nor did I know that he had been obsessed with painting since he was five years old and first walked into the studio of his painter-uncle, Louis Cartier-Bresson, who had won the Prix de Rome only a year or two before.

Like most other people, I thought of Henri Cartier-Bresson as a photographer who for many years had been changing the way in which we look at the world. A master of instantaneity, he was the man who moved in, pressed the button and moved on.

I also remembered what Lincoln Kirstein, connoisseur, historian, and cofounder of the New York City Ballet, had written in 1947: that in his photographs we are aware of 'the basic wisdom of the West: how men say they behave, how they pretend to behave, and how they do behave; what "stands

to reason"; what is "Common sense"; what is, ultimately, true. For Cartier-Bresson is a moralist. He is not interested, ultimately, in the propriety of an ethic, but in *les mœurs,* the actual, essential behavior of men.' Who among us could have known that, for that same stalker of realities unrevealed by anyone else, the slow, wracking effort of painting and drawing had always outranked photography?

'I was never deeply interested in photography as such,' Henri Cartier-Bresson said not long ago. 'My great passion is pressing the trigger of the shutter: an instant, intuitive drawing, but it does not have the element of graphology which is provided by drawing.' When he was a prisoner of war in Germany during the Second World War, a fellow-prisoner asked him what he intended to do after the war. He had already made photographs that gave him a place of honour in history, and yet 'I shall be a painter,' he said, as if there could never be any doubt about it.

However, it was not until nearly thirty years after the end of the Second World War that the decisive moment arrived. It was owed to Tériade, the editor of *Minotaure* and publisher and editor of *Verve* magazine, who had been a friend of Cartier-Bresson's since 1931. 'You've given forty years of your life to photography with a painter's eye,' Tériade said. 'You don't have to do it any more. Take stock of yourself and draw.'

Henri Cartier-Bresson was, as it happened, a partisan of the clean break that marks off one phase in life from another. In his catalogue essay for *Henri Cartier-Bresson: The Early Work* at the Museum of Modern Art in New York in 1987, Peter Galassi recalled how in 1930 Cartier-Bresson had jumped ship on the Ivory Coast of Africa while on his way back from the Cameroons. 'I took off and made my living in Africa as a hunter, with an acetylene lamp,' he said many years later. 'I made a clean break.'

Unaware of severances such as these, I thought that his drawings had to be a pastime, or a relaxation. But then it seemed to me that there was something uncommonly tenacious about them. Somewhere within them was the man who, when asked if a week would be enough for him to have the freedom of the Museum of Natural History in Paris, moved in there every day for eight months.

To a degree that still seems extraordinary, he banished from his drawings the elements of speed, sleight of hand and all-seeing social comment that had marked his work as a photographer. Of what he had learned as an assistant to Jean Renoir during the making of *Une Partie de Campagne* and *La Règle du Jeu,* just before 1939, there was never a trace.

Nor can we sense in his drawings that he has been one of the great travellers of our century, at home in all societies and all four continents. From the moment that he took Tériade's advice, he was back where drawing began: a man, a pencil, a sheet of paper and a board on his knee, with zero as the point of departure and subjects found close to home.

As to what actually happens when Cartier-Bresson picks up the pencil and relearns the alphabet of seeing, Jean Clair is the best of guides. I will say only that in drawing as much as in photography, though not at all in the same way, Cartier-Bresson's subject is still '*les mœurs,* the actual, essential behavior of men' – and not of men only, but of great cities, millenary skeletons and young women with or without their clothes. A life-long prowler, alert to whatever subject presents itself, he has once again opted for the clean break and sits as if chained to the drawing-stool and the board on his knee. We are the richer for it, and so is he.

Introduction by Jean Clair

Henri Cartier-Bresson has long been considered one of the great photographers of our age. He has become so identified with his art and has illustrated its potential so expertly that when one sees a wonderfully simple yet moving photograph one automatically wants to say, 'It's a Cartier-Bresson' – just as one says 'It's a Picasso' when faced with a powerful painting. A silent wading bird with a Leica hanging nonchalantly from his right arm, he looks like a child with a catapult. I've seen him edge his way into meetings and crowds with the sureness and charm of a hero in a play by Beaumarchais. He has the same sense of ease, the revolutionary outlook, yet also the grace and the ability to delight. He lets himself be carried along by the situation, like a bird in a gust of wind. Cartier-Bresson's art is easier to appreciate when one has seen the photographer glide by, buoyed along by an invisible breath of air, suddenly spotting what no one had seen and capturing it without exerting any pressure, seizing its likeness without a sound, without even taking time to position himself for the shot... then move on just as quickly, elated with his catch. Only someone captivated by life itself could take such photographs.

About fifteen years ago Cartier-Bresson decided to put down his camera and take up drawing again. As a photographer, he had lived by plundering, by hunting and gathering, and by taking large risks. Now he decided to live by slow and patient farming. Cartier-Bresson had been an adolescent in the 1920s, in the heyday of the international reporter whose exploits were featured in the illustrated children's magazines of the time. Wasn't it Stendhal who established the term 'reporter' in France in the years after 1829, importing it from England with the same self-confidence that characterized his dandified way of walking? Cartier-Bresson, a fair-haired, elegant man with clear, piercing eyes, did, in fact, live the life of the eternal youth, touring the world like one of the heroes in those books he devoured. As a child he was quite content with his fortune, with Arsène Lupin and Fenimore Cooper, just as he would have been with Karl May, had he been German. Yet he was also inquisitive about more 'serious' books, about those which recounted the travels of Henri de Monfreid in far-away places or, nearer to hand, about the adventures experienced by Arthur Rimbaud and André Breton in the jungle of the big cities.

Too quick to be noticed, Cartier-Bresson took pictures that he later compiled in books whose quality will be admired for centuries to come. No one will ever have the same light and mercurial touch as he has. Indeed, 'mercurial' is the word that defines the essential quality of a photographer, just as gravity or wisdom are part of the philosopher's nature.

Having arrived at the middle of one journey, 'nel mezzo del camin', he decided to return to his first passion, to drawing, just as others turn to gardening or some other pastime. His friends and colleagues were stunned. Some of them smiled, realizing that the famous photographer had simply moved from a dark room to one that was lit. But other, less understanding, observers thought that the old man was simply giving in to a whim. They had forgotten that Cartier-Bresson possesses, and will always possess, the special gift of childhood, that genius one can, according to Baudelaire, rediscover at will and which was now expressed in drawing with the same ability to surprise and to charm that had so marked his photography.

After all, Cartier-Bresson's first ambition was to be a painter. The artist and teacher André Lhote had supervised his first attempts rather casually, without venturing to guide the adventurer: 'You're a little Surrealist,' he said one day, 'the colours are nice... carry on!' An uncle, a fine painter now somewhat forgotten,[1] had acted as a father figure

[1] Louis Cartier-Bresson was born in Pantin near Paris in 1882 and died in battle during the First World War. He was a student of the painter Cormon and received the Prix de Rome in 1910.

for the young student, thus reinforcing the influence of Cartier-Bresson's real father who also had a fine visual sense and a talent for drawing. In one of his very few written statements – one of the most penetrating and lucid treatises on photography and moral philosophy of our time – Cartier-Bresson reveals a secret love which should be taken to heart: 'I always had a passion for painting,' he says with a frankness that is quite arresting in a preface to a book of his photos. 'As a child I painted on Thursdays and Sundays, when school was closed, and dreamt of painting the rest of the time.'[2] Then, quite unexpectedly, a little Brownie-box appeared, captured the boy's interest and sent him off in a new direction. This sudden change of heart is rather puzzling. Photography seems to have served as a screen behind which another dream evolved. While presenting a succession of remarkable images to the outside world, Cartier-Bresson secretly longed to capture experience by different means.

Photography is considered to be similar to drawing because it registers forms in black and white on paper. But this similarity is misleading. Photography is much closer to the art of bronze sculpture, because corrections are not allowed. Once an object has been cast, there is no going back. The work is fixed forever. The same applies to a photo: it should not be retouched or cropped or manipulated in any way. The photographer and the bronze sculptor work in the same fashion. They do not concoct images, they fix the characteristics of the object once and for all. There is no place for indecisiveness or imprecision. Drawing is different: hesitant and fluid, it comes into being like music. It is built up, is rubbed out, is added to, disappears or takes shape. Rarely does it show unswerving determination.

Who can say where the labyrinth of memory will lead, or the imperatives of a dream? One day in 1973, Cartier-Bresson's most faithful and vigilant friend, the art publisher Tériade, said to the famous photographer, 'You've done as much as you can with photography, and if you go on you will only start taking steps backwards. What you ought to do is to take up painting and drawing again.' A man of less experience would have been shocked, but the photographer remembered the painter he had always wanted to be. Was this a *vita nuova*? Tériade was far-sighted: painting and drawing soon became the photographer's principal occupations.

Yet, the importance of the transition from photography to drawing should not be overstated, for the artist's eye and mind did not change fundamentally, even if the technique and the way of looking did. His photography and his drawing are two aspects of the same activity. There are many examples of painters who were also photographers. It is easy to forget that Degas, Toulouse-Lautrec, Vuillard and Bonnard were all enthusiastic photographers and that, without the influence of the camera, the paintings of all four would have been quite different. Photography was a way of sharpening their vision, at once a welcome alternative to painting and a revelation of its more obscure and unsuspected side. A photograph expressed many things that a painting could not say. In his photographs Degas seems preoccupied with shadows, silence, mystery and lack of movement, while his paintings are characterized by movement, light and immediacy. All his postulates are reversed. His photographs demonstrated that reality could consist of shadow, night, silence, and stillness, whilst his pastels acquired spontaneity, brilliance and boldness. His photos, in fact, assumed the qualities of traditional painting, setting his pastels free to discover new horizons.[3]

[2] *Images à la sauvette: Photographies par Henri Cartier-Bresson* (*Verve,* Paris, 1952; translated in English as *The Decisive Moment,* Simon and Schuster, New York, 1952).

[3] See Antoine Terrasse, *Degas et la photographie* (Denoël, Paris, 1983).

It seems obvious, on reflection, that such an accomplished photographer as Cartier-Bresson should want to return to drawing, not in order to prove the truthfulness of photography but to see what is there, in front of the lens, after the camera has been set down. There is little doubt that he would have been a painter if he had not become a photographer: his life as a photographer was a long apprenticeship in learning how to see.

When I watch Cartier-Bresson at work, I am astonished by his serious expression. The photographer's eye was 'quick' – like the quicksilver used to develop the first daguerreotypes. By contrast, the artist's eye is probing. The photographer never had time to think, he captured something in a magical split second. But the draughtsman thinks; he is constantly pondering the value of what should or should not be committed to paper.

When he lowers his eyes to look at the nude stretched out in front of him, it is as though he has just laid down his arms. The draughtsman is not interested in seizing his prey but in allowing it to live in complete freedom like a wild animal which the eye, aided by slow and repeated movements of the hand, tries to understand and to tame. 'Doesn't that tickle you?' he suddenly asks his model. 'Don't you feel anything?' he says, as if the act of looking at the model's body was somehow like touching it with his hand. The line drawn by the pencil is like a finger that follows the curves and runs up against the knotty junctures of the flesh. The line tries to describe a protruding hip, a straining stomach or a deep breath. The artist's serious and steady expression reveals at one and the same time his clinical way of looking at reality and yet his loving concern for it. Instead of registering images almost before they are recognized, as was the case with photography, his eye now reflects astonishment and anxiousness by turns. The photographer sets out to capture reality and to confirm the existence of something. He tells us that reality exists since it produces shadows. The

draughtsman, on the contrary, constantly doubts the existence of reality. A sentence from Goethe's *Italian Journey* sums up his feelings: 'What I haven't drawn, I haven't seen.'

It was no accident that Cartier-Bresson's first drawings, in 1973, were geographical reliefs, views of landscapes, of the Mediterranean, of the Plan de la Tour in southern France and of the Tuileries Gardens in Paris, which his flat overlooks. He needed to find his bearings, to discover where he belonged after more than forty years of globe-trotting. The taxing transition from a rapid and technically advanced form of recording images to the slow, patient and precise sketching once practised so elegantly by English country topographers came about in response to a real need.

Like a priest without a compass trying to determine the best orientation for a new church, Cartier-Bresson turned to drawing because of the special way in which it demarcates space and fixes a centre. Establishing a spatial identity went hand in hand with creating an historical order, and the second series of drawings reflects this. Completed for the most part in the Museum of Natural History in Paris in 1976, they depict the skeletons of giant animals which lived on our planet long before man. It is as if the photographer needed to rid himself of an old preoccupation with the split second by focusing on the heavy legacy of thousands of years in order to give some weight to his new undertaking. His drawing had to catch in its net the immensity of space and the infinity of time before he could tackle his principal ambition, which was to draw the figure and, by drawing it, put it back in the centre of the world and in the centre of time.

'How long do you want?' asked the Museum's director. 'Eight days?' Cartier-Bresson stayed eight months. No amount of time would suffice to count and re-count the vertebrae of the dinosaurs that seemed to come alive again under his eyes. The Bible says that on the day of Resurrection not a hair of anyone's head will be missing from any of

God's creations as He will have counted them all. Cartier-Bresson has never worried about omitting one or adding one; Ingres, who did add extra vertebrae to his models, was more truthful in his painting than a photorealist who attempts to subjugate reality for ends that are not his own. The painter is the guardian of appearances, but he is not their accountant. Painting is more like a scale than a yardstick, more a weighing up than an enumeration. A photograph shows forms assembled in an order which, from an isolated detail, gives an idea of the whole and – by implication – of the immensity of time and space. A drawing is less concerned with reflecting the order of things than with stressing its own materiality: it convinces us less that the world exists around the drawing than that the world itself *is* and that drawing is a part of it. We don't tend to doubt the truthfulness of a photographic portrait: Baudelaire, we feel, had just the features that Carjat recorded. However, to wonder whether a painted portrait differs from the subject is quite another thing. We haven't the slightest idea how faithful the likeness is and, in a sense, we don't care. The painting exists in its own right, independent of the vulnerable face and transitory expression that are represented. Courbet and Fantin-Latour also portrayed Baudelaire, but we wouldn't be disturbed to learn that their portraits were not faithful. Thanks to its coherence as a metaphor, and not to its fidelity as a transcription of the visible, a drawing testifies that nothing in creation has been neglected. The draughtsman is indebted to the visible world: he brings to life a visible world that has been lent to us by God. Yet drawing renders this vision without quantifying all the details: it inspires faith, and rests upon its own truth. The photographer, on the other hand, confirms the world's factual appearance but also desecrates it by necessarily omitting to offer the complete context of a picture.

And so this man, who had spent a lifetime tracking and pinning down reality, suddenly seemed to have stopped believing in the testimony of photography. Now he wanted to verify, slowly and patiently, that the world offered a set of continuous appearances. Toward the end of his days Cartier-Bresson had a change of heart which, for a great creator, is like a new lease of life; he began to doubt again, like a child, though more in the spirit of Buddhist astonishment than of Cartesian scepticism, and began to reconsider what only yesterday had seemed to be completely obvious. The sense of wonder that is often apparent in the late works of painters can also be found in Cartier-Bresson's. The tiniest things astonish him, while reminding him with a jolt that the world *is* and that it continues to be: the way an armpit turns into a shoulder, the way a nipple juts out, the way an eyebrow curves along a forehead. Despite his age, Cartier-Bresson acts like a serious, astonished child who doubts that certain things really take place. He feels that he has to re-evaluate his past experience.

Drawing, as it is practised in the West, requires a kind of faith. It is a way of affirming the incarnation of the world, its material and enduring reality. But the photo, as an image that surges out of the void, a silver-grey breath floating over a scrap of paper, illustrates those oriental parables that say all life is contained in one moment and that one moment can open on to another life. Where photography reveals the world's emptiness, drawing shows its vanity. Henri Cartier-Bresson's drawings affect us because they have the striking vulnerability of his photos: one feels, in both cases, that appearances are based on a void, and that drawing's perennial vocation is to register their ever-changing presence.

After drawing landscapes and prehistoric animals, Cartier-Bresson turned to the nude, a subject rarely treated in his photography. While so many photographers, from the most refined to the most vulgar, have made the nude the key element of their art, Cartier-Bresson showed only occasional interest in the theme, and that was characterized

by discretion and reserve. Nonetheless, his *œuvre* contains some of the most erotic images of women that the lens has ever caught: lesbians in Mexico, nude studies of Leonor Fini, the remarkable Bali pictures of 1950.

In photography a strongly antagonistic relationship exists between the photographer's furtive, precise and prying glance and the vulnerable nude subject. In a portrait, the nude, by definition, is exposed to the indiscreet lens of a camera. A nude can be violated by the camera, just as an intimate expression on a face can be violated. Photographing the nude is, willy-nilly, an aggressive act. Taking a photo is at once a physical act and a substitute for a physical act; the click of the camera is akin to a physical discharge, and the resulting document – moist and smooth – fixes the feeling of the moment. To disregard the basic truth of photography's aggression and to photograph female nudes with today's profligacy is to break one of our culture's most powerful and protective taboos. If contemporary photography is besotted with the nude – and the growth, reproduction and vulgarization of photography owes everything to it – the reason lies in the fact that the nude is the most secret part of the visible world. The fact that our image of the nude has been remade by pornography and publicity is a sign that our culture is forgetting its basic principles.

If Cartier-Bresson abandoned photography in order to return to drawing, it was perhaps because his instincts told him that drawing offered possibilities not allowed by photography, namely the proper study of the female nude, that touchstone of art. It was no longer a question of capturing the nude quickly as photography demanded, but of taking his time to study the nude lying motionless in front of his eyes.

The nude is the draughtsman's most challenging exercise: in a landscape it does not matter if a branch or several leaves are missing, but no such latitude is allowed when one draws a nude. To draw the nude is to combine rigour and a sense of excitement. To draw the nude is to 'master' both the power of sexuality and of death.

How does one combine the whole and the parts? How does one proceed from the whole to the detail and from the detail to the whole? How does one stop the whole from disappearing from the fragment that one does manage to capture, and, if the whole is captured, how can the fragment be saved? Bereft of the Renaissance theory of human proportions, a modern artist can only use his eye empirically. Whatever Cartier-Bresson may feel, *Le Traité de la figure* by his former teacher André Lhote is tedious and useless. The contemporary painter is defenceless when faced with the nude; his view is nude, especially behind the shield of a camera.

As a result, the hand is left to make a judgment: it draws a few lines, rubs out some others, suddenly rises in a moment of indecision and hovers in the air like a bird, its shadow falling over the paper. The perpetual movement of the eye back and forth from the model stops the hand from indulging in fantasies and the eye from being overwhelmed by the model's beauty. This movement, this weighing up of many factors is the essence of drawing. Drawing strikes a balance between the blank sheet and the physical model, between fantasy and reality. In this back-and-forth movement, the mind leaves its own enduring mark.

'Can I see how you made your foot?' He pauses and corrects himself: 'I'm sorry, I mean how your foot is made? What position was it in?' The draughtsman's whole body is activated like a pressure cooker; he puckers his mouth, wrinkles up his nose, then sighs. As his impatience grows, Cartier-Bresson seems to steam from every pore. Drawing has ceased to be a pastime, has long ago stopped being like an arrow that quivers, flies through the air, and hits its target. It is important to concentrate whilst drawing, so as not to let anything escape. The Leica was an extension of the arm, more a natural than an artificial apparatus. But the pencil is an artificial addition to the hand, a prosthesis that requires constant supervision.

Whereas the photographer depended on an instantaneous click, on the sudden opening of a shutter, the draughtsman has to cope with, and fight against, the visible world fragmenting continually in front of his eyes.

Photography is essentially surrealistic in that it surpasses every other form of expression in its power to objectify what the Surrealists called 'objective chance'. Henri Cartier-Bresson's aesthetics have – with good reason – been compared with those formulated by André Breton around 1925.[4] With greater success than Breton's automatic writing or his famous encounter with Nadja, the Leica cuts straight through the tangled confusion of possible encounters in order to pick out the one that matters. Far from vindicating a naturalistic point of view, photography leads more directly than any other art form to the 'marvellous' of the Surrealists. Drawing, by contrast, like thought (as Paul Valéry tells us), is a product of the mind and the fruit of patience. There are few, if any, 'given' or spontaneous drawings, few, if any, drawings with a truly 'convulsive' or immediate beauty. Some graffiti, some spontaneous gestures or certain rapidly executed sketches may possess such beauty, but never more than a hint of it. This hint must be made palpable and – what is most daunting – must be honestly transferred as a mere hint on to paper. Drawing not only comprises the act of searching but also the acts of correcting and revising. 'Photography', said Walter Benjamin with great perception, 'is the unconsciousness of sight.' Photography is a semi-conscious act carried out at a kind of heightened level of reality comparable to the enlightenment for which a Zen monk strives; everything takes place at an intuitive, precognitive, and instinctual level. The camera may be a highly sophisticated machine, but the person who uses it must paradoxically call upon the oldest functions of his brain. By contrast the draughtsman is entirely conscious and integrates his consciousness into his work by constantly revising and planning. Drawing appeared at the first stages of civilization: the logic of a line, the decision reflected in a contour, the elegance of a curve – all bear witness to the brain's intelligent use of the hand. The catapult of a child, the photograph is the most recent version in a long line of throwing devices that began with sticks and stones. Like all machines, it takes one back to primitive times when language did not exist. Photography is introduced wherever unconsciousness rules. A great photographer is perhaps just someone who has a special ability to exploit his full potential – an ability that no doubt existed in the camera obscura of man's origins.

'There won't be any feet,' Cartier-Bresson concludes, as he finishes this first drawing. The photograph swallowed everything in a second but the drawing cuts into one's vision and does not respect the whole object. If Degas and Bonnard used a kind of photographic frame in their drawings, it was not because they had grown used to the way the photograph cuts into space; rather, it was because they knew how avid the lens is to devour everything. And so in their drawings they made a virtue of a natural, fragmented vision which cuts bodies off in accordance with the format of the page.

The photographer's temperament is still present in the draughtsman's impatience to complete his drawing. Yet one does not finish off a drawing as a hunter finishes off his prey: on the contrary, one must encourage the still life to live – so that it can be captured alive. As with anything magical, the only way of bringing it to life is to take one's time and to concentrate. In contrast to the flash of a photograph, which, just like an erotic act, requires the secrecy of a darkroom to be developed into an image, the pencil's coal-like deposits are added slowly, in the full light of day, in the camera lucida of the studio – by a hand which, paradoxically, gropes in the dark.

[4] In Peter Galassi, *Henri Cartier-Bresson: The Early Work* (Museum of Modern Art, New York, 1987).

By the third sketch Cartier-Bresson's expression has become almost restful. An agreement has been struck. His hand moves across the paper with the ease of a hand caressing a beloved body. The sweeping movements of the artist's wrist reflect the same lines of the reclining nude. Every now and then, the artist stretches like a cat that has spent the last hour or two in the motionless contemplation of its surroundings. The world carries on but the drawing is finished. The model seems to have fallen asleep. Trusting in the draughtsman, she seems to have yielded to him, as one yields to warmth and to repose.

'What is going on here is quite complicated,' the artist confides, as he begins his fourth nude sketch. He has come up against some problems. As she turns her neck, the model's face partially disappears from sight, revealing an angular profile. Now that her jaw is aligned with her shoulder, everything has become heavy and contradictory where, just a moment ago, the pencil was moving effortlessly to form the curve of the hip and the thigh. The whole process will have to start again – not only to assure the artist of the validity of his undertaking but also to find the unity in this body that has suddenly become so disjointed.

'We'll talk about the legs some other time,' he exclaims, almost defeated by the last drawing. Yet, still agile and buoyant, Cartier-Bresson begins again, his mind fixed on the next one.

Translated by Thomas West

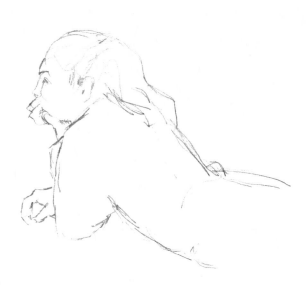

M.C B a la Télé
H C B
82

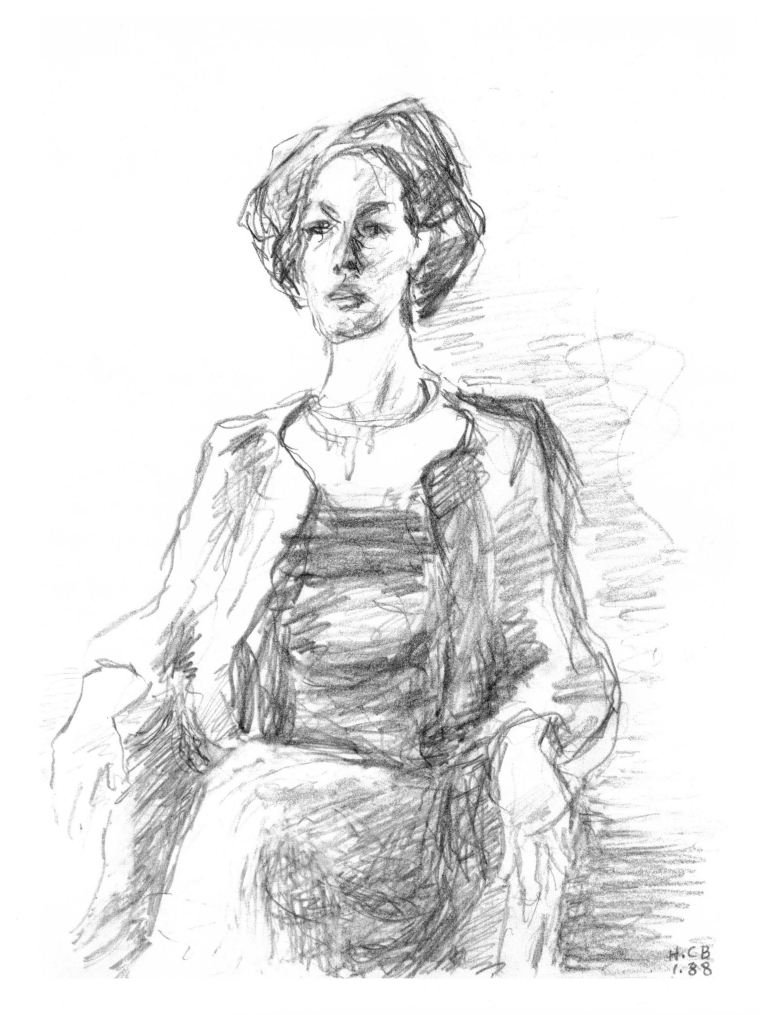

H.CB
1.88

23

H.CB 7.73

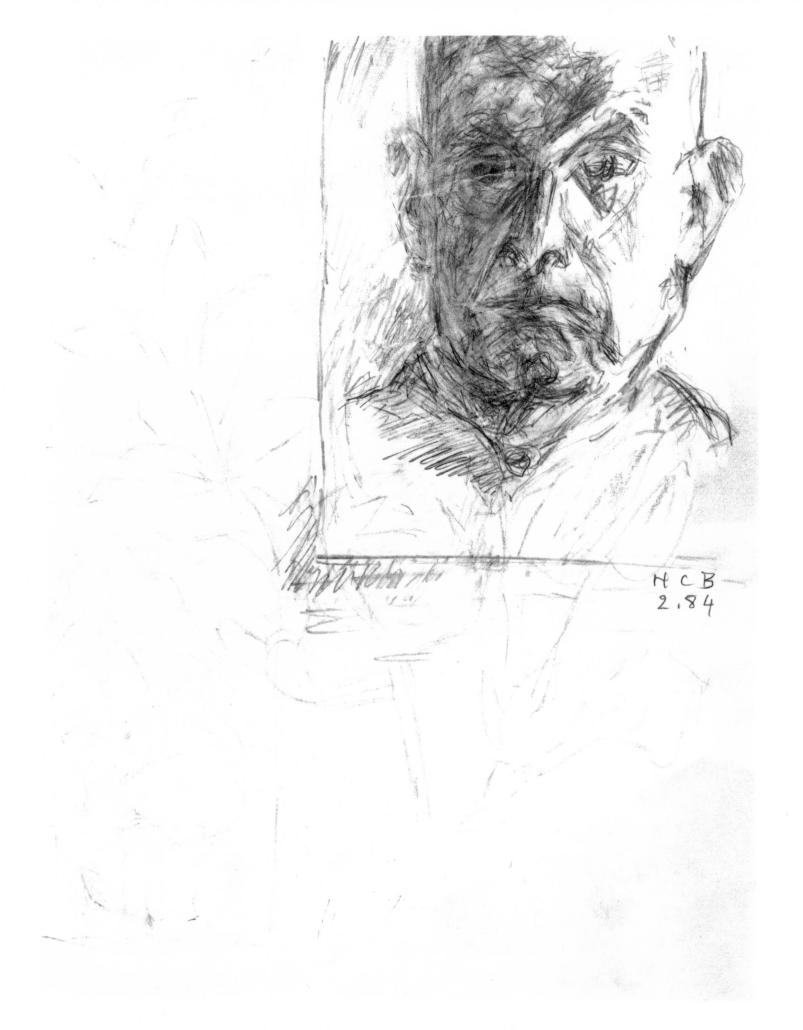

HCB
2.84

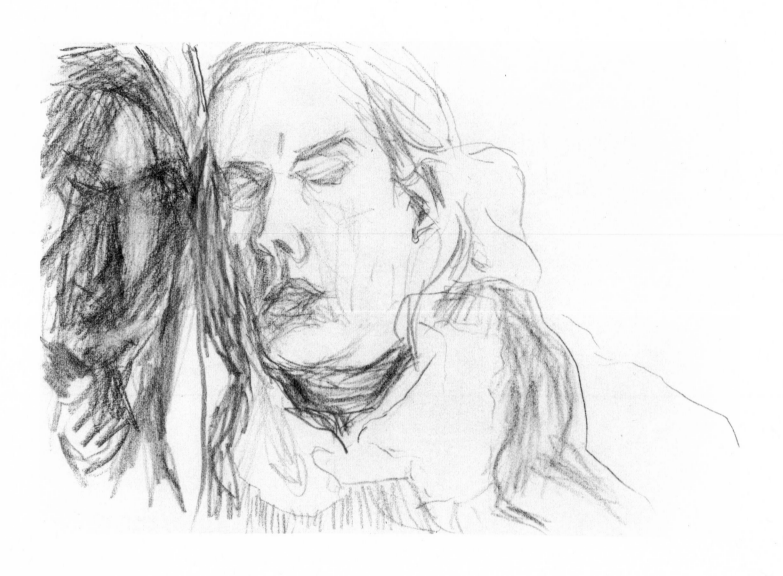

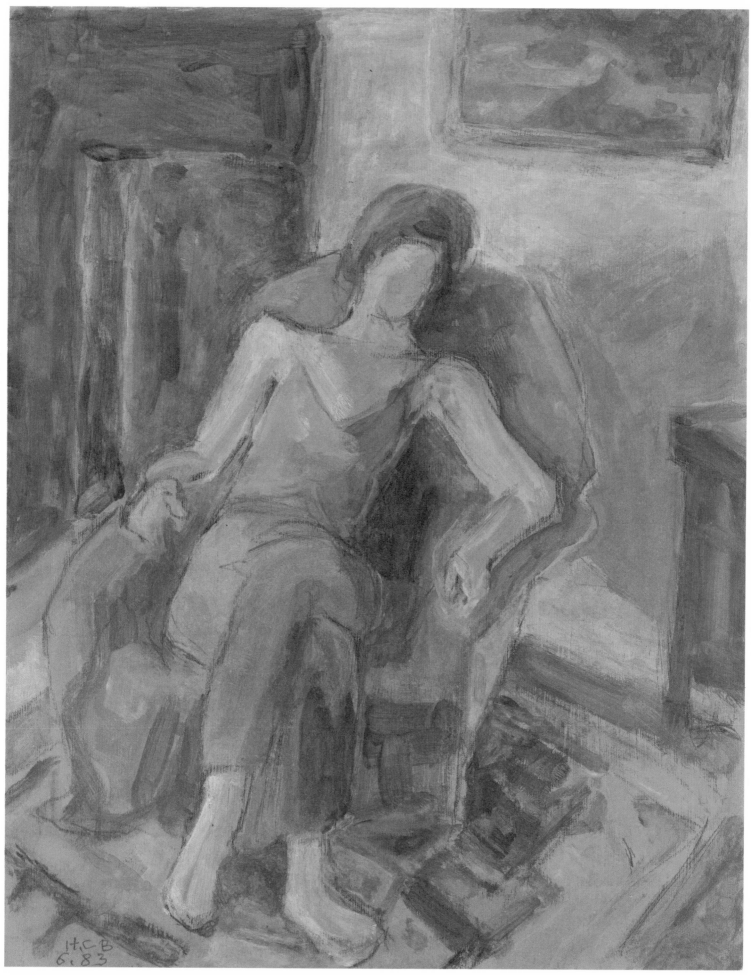

HCB
6.83

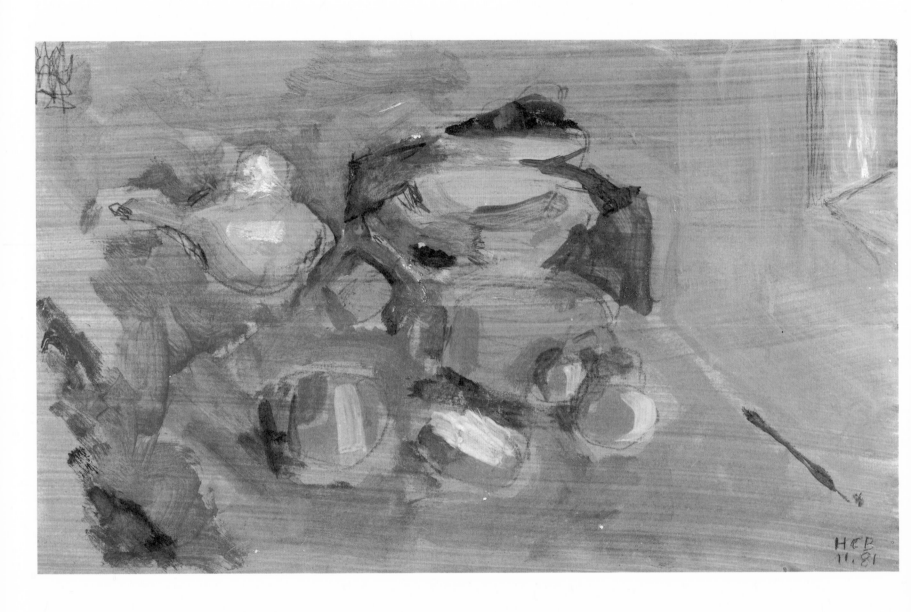

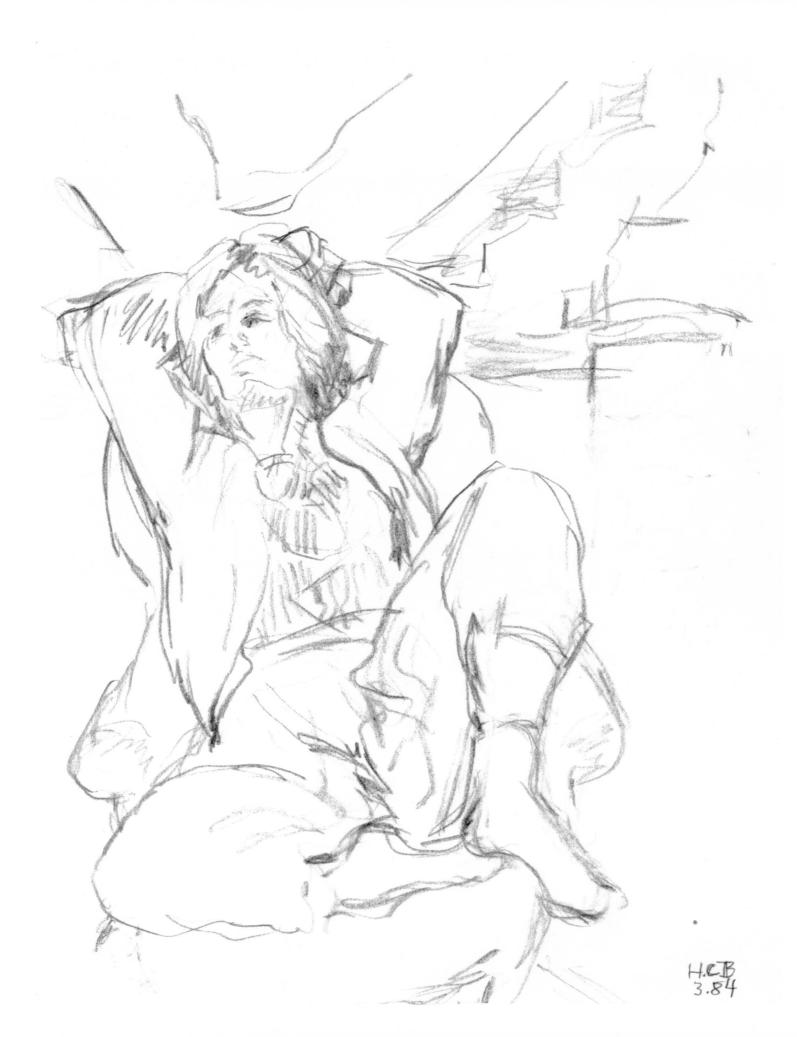

H.C.B
3.84

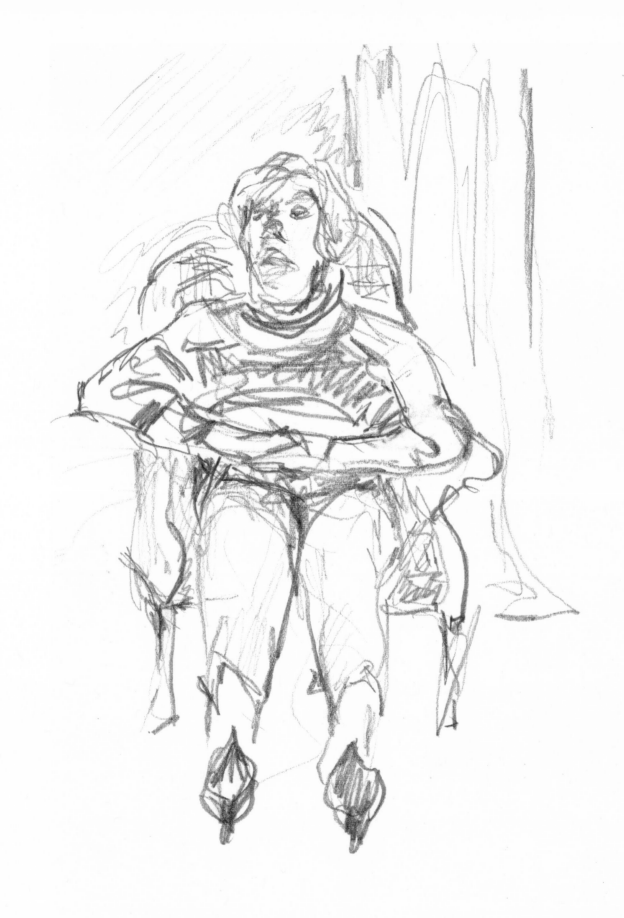

HICB
83

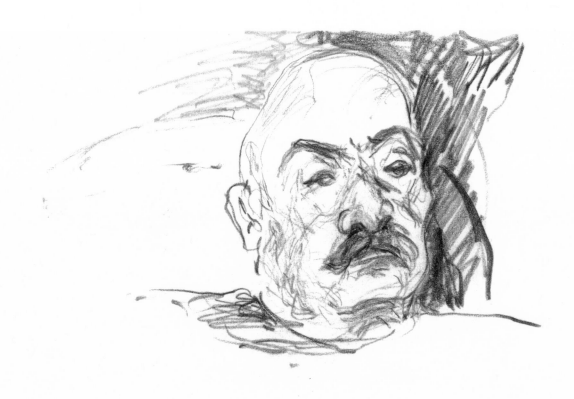

H.C.B
11.78

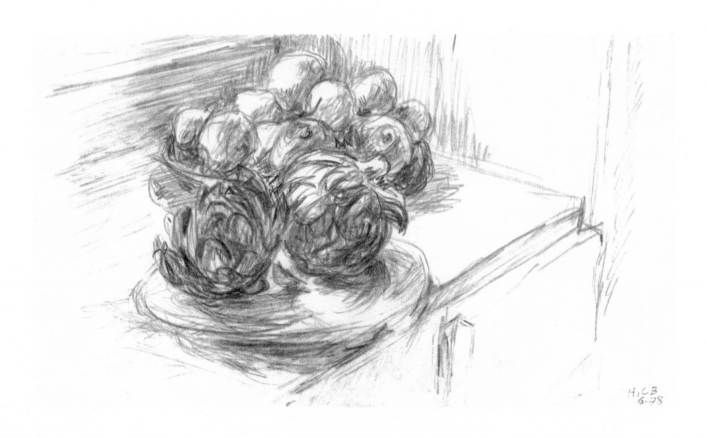

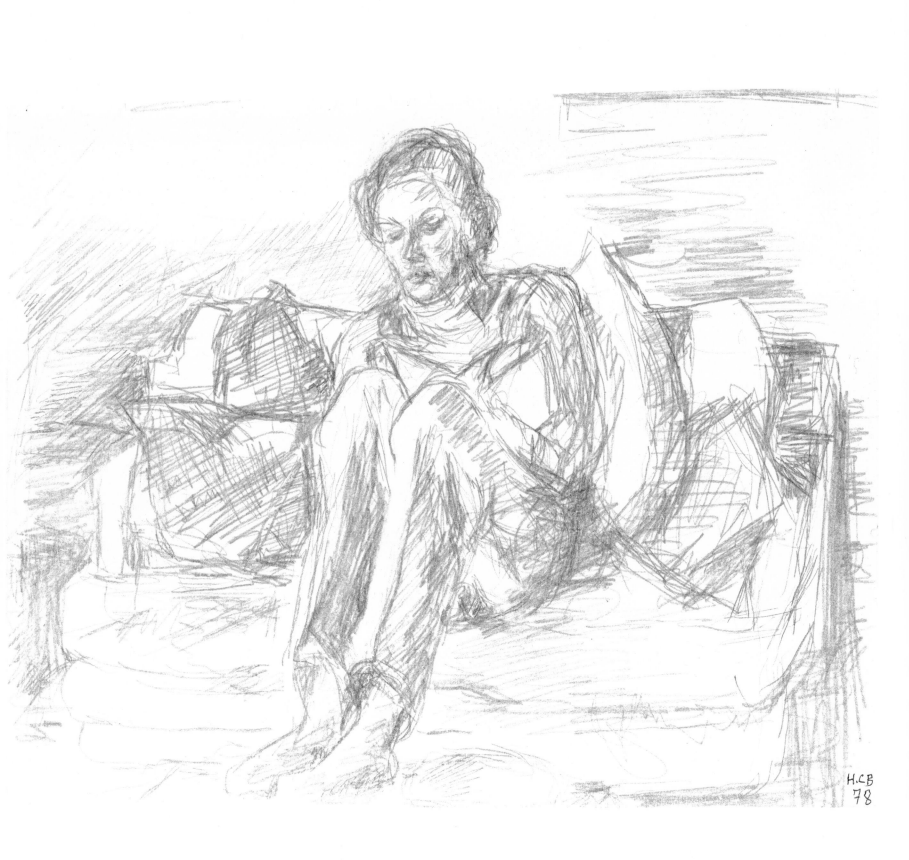

H.C.B
78

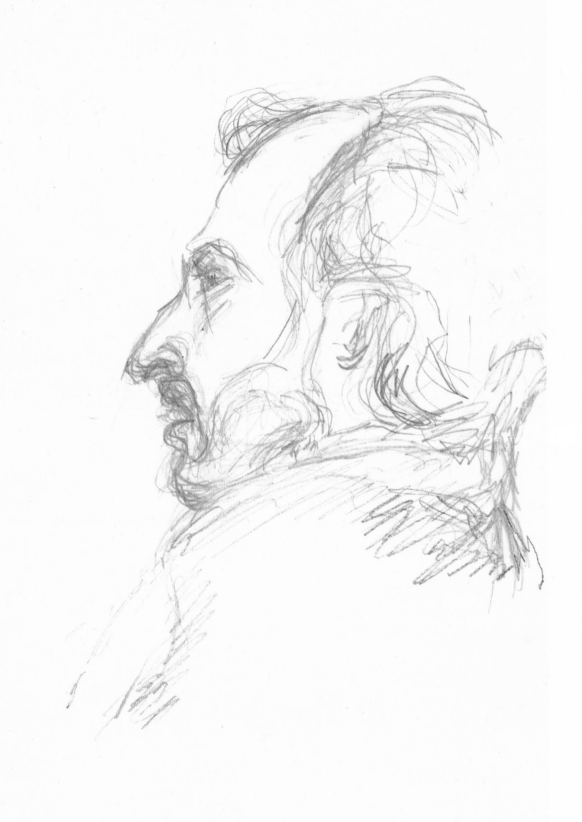

H.C.B
9.77

34

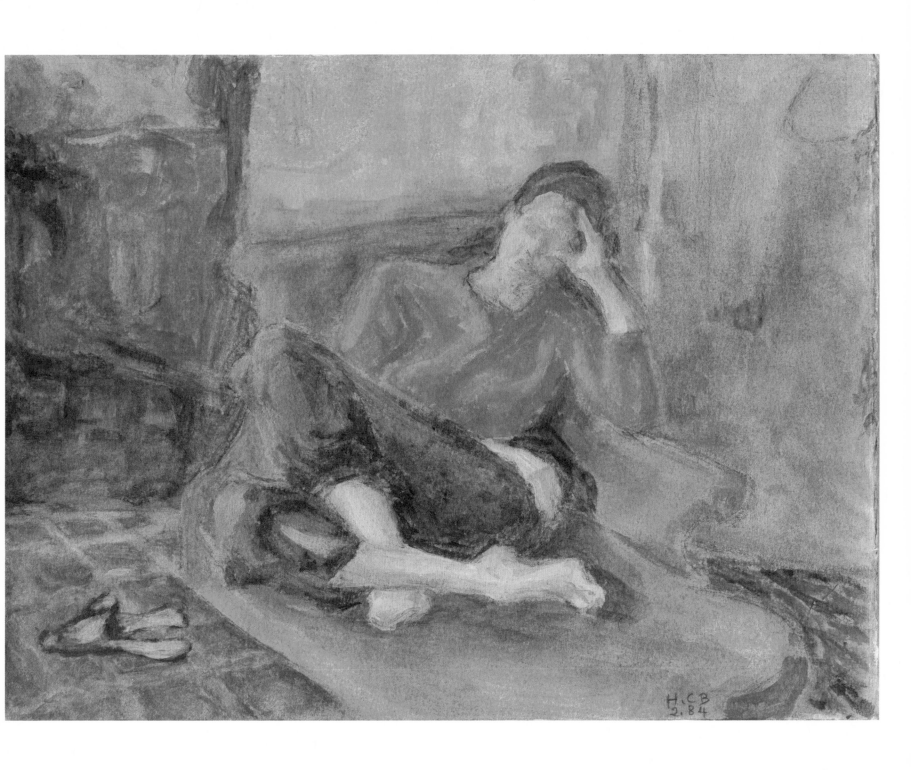

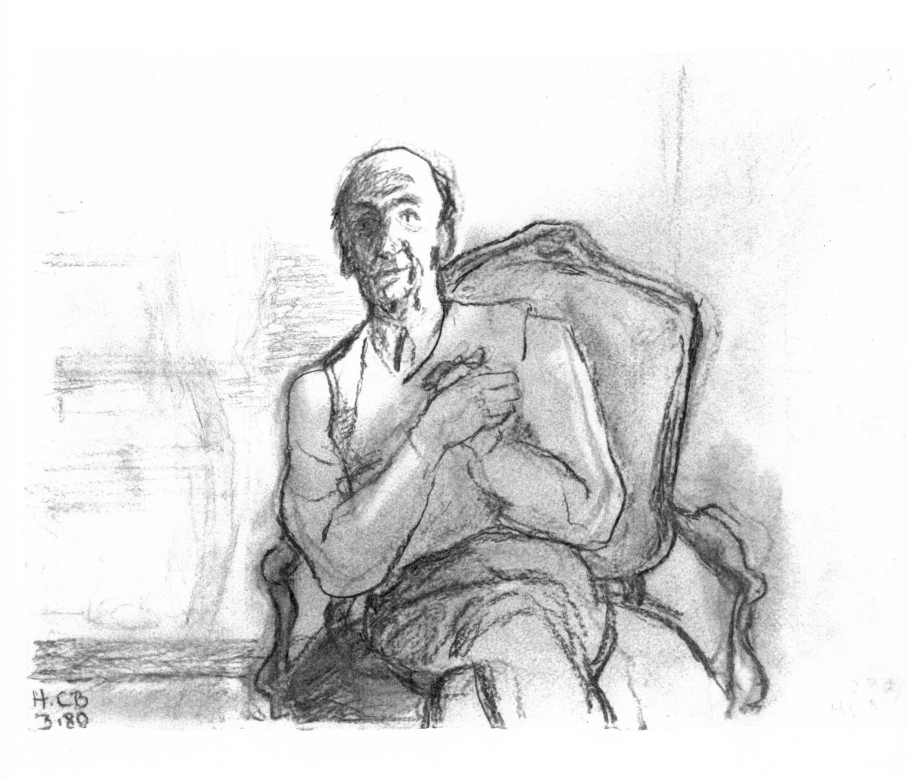

H.CB
3.80

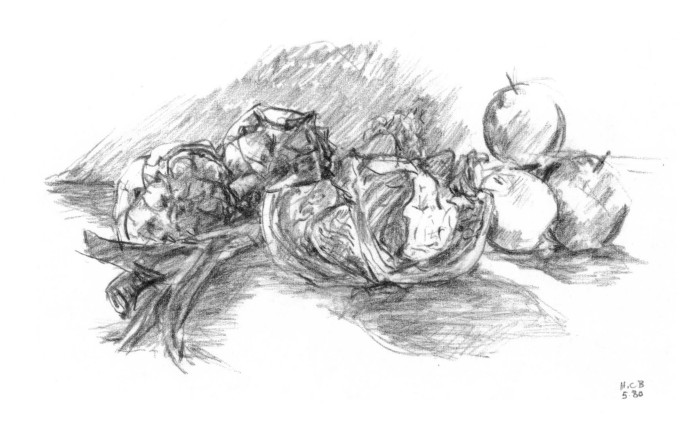

H.CB
5.80

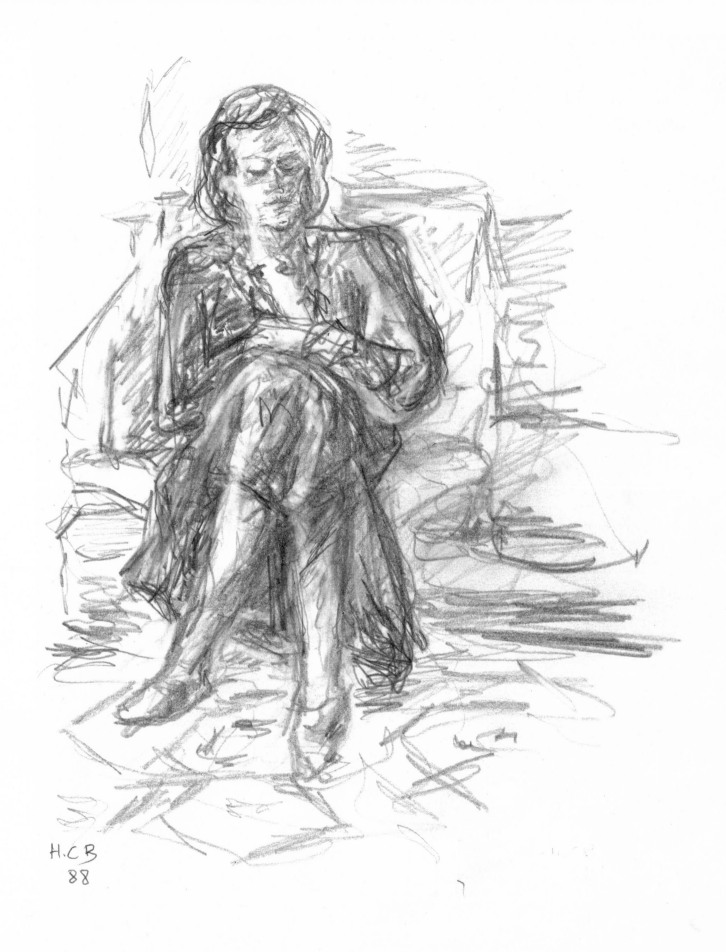

H.C.B
88

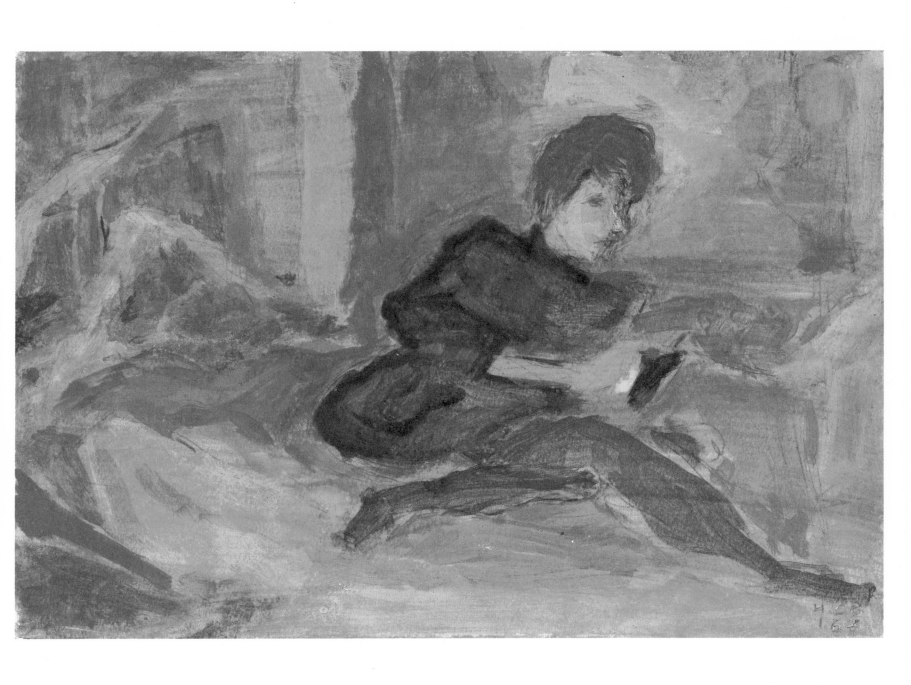

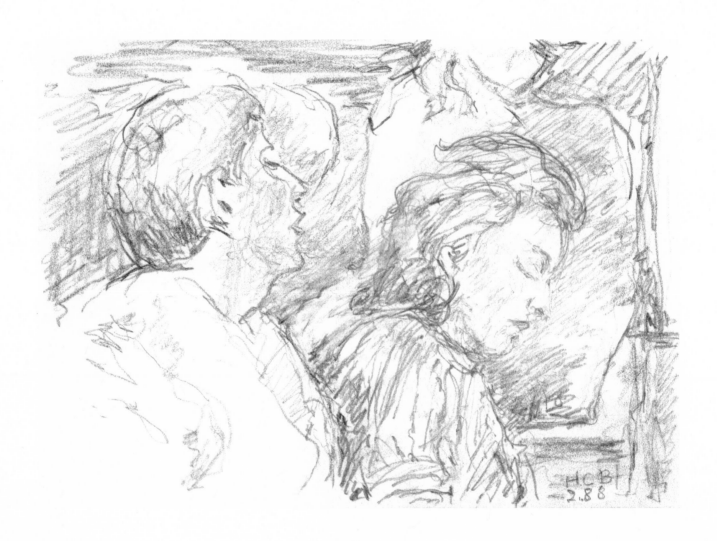

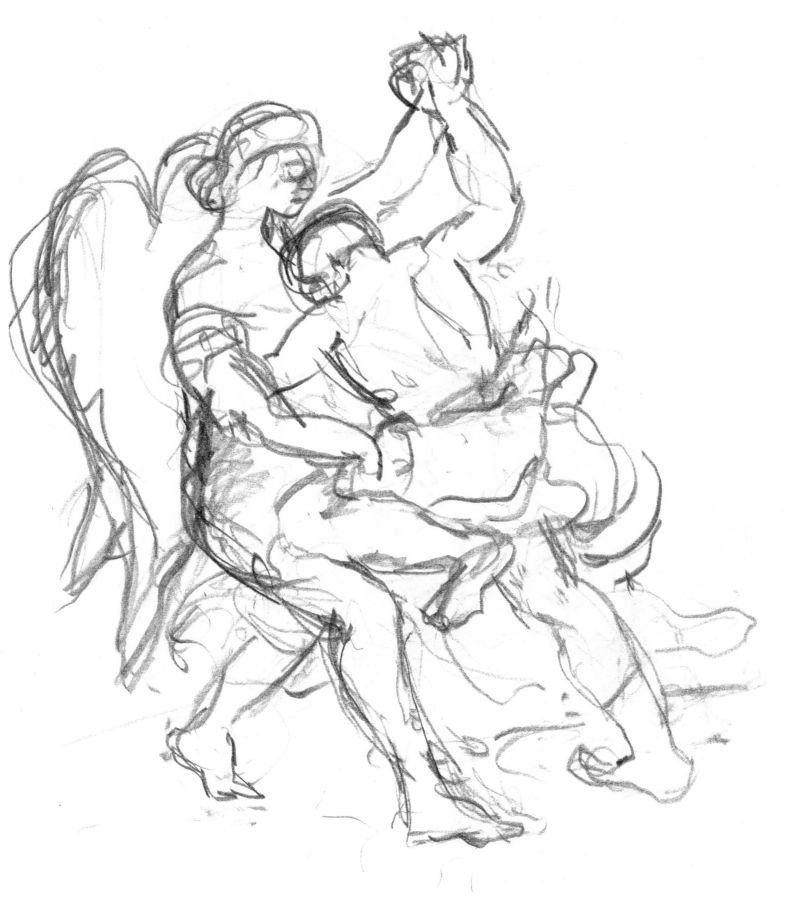

H.CB
87

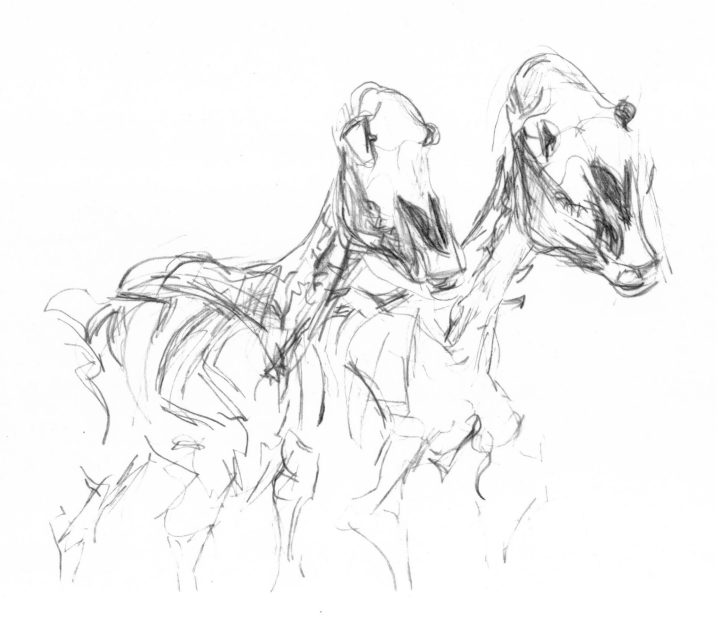

H.C.B
1.76

43

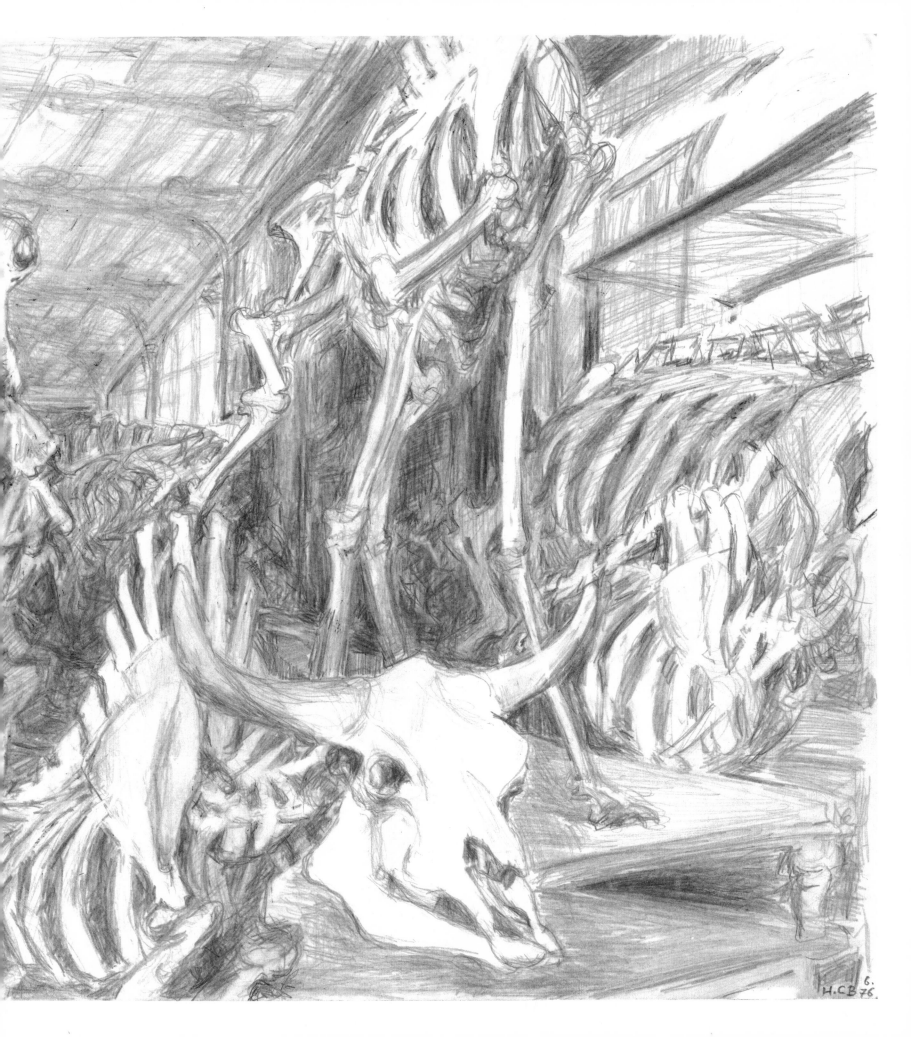

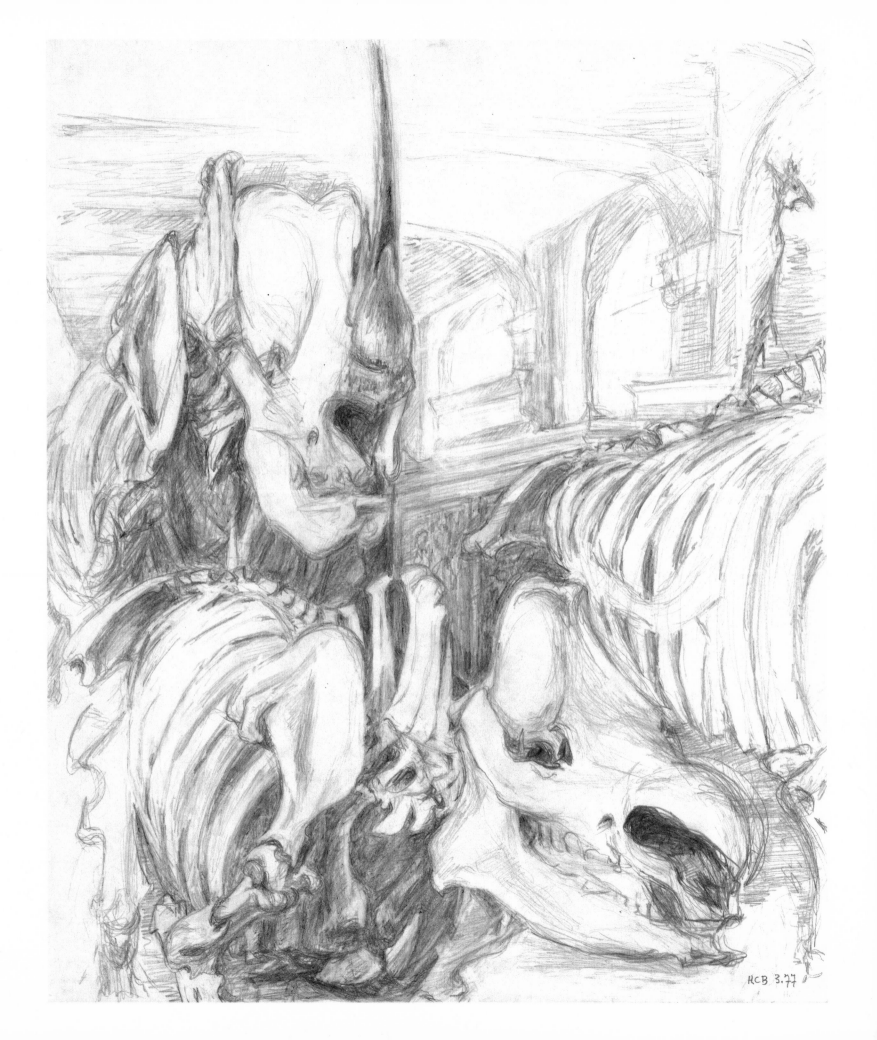

HCB 3.77

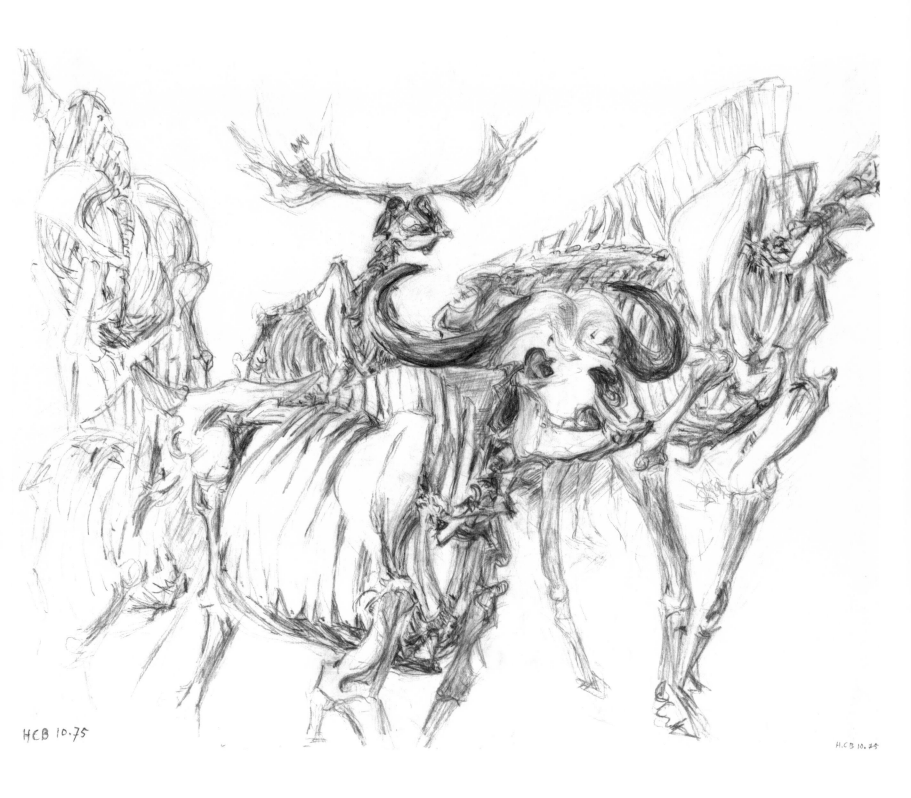

HEB 10.75

H.CB 10.75

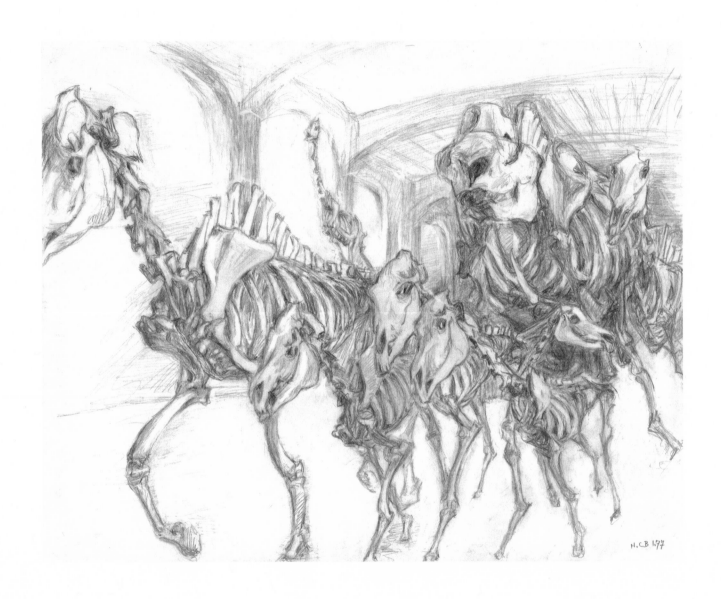

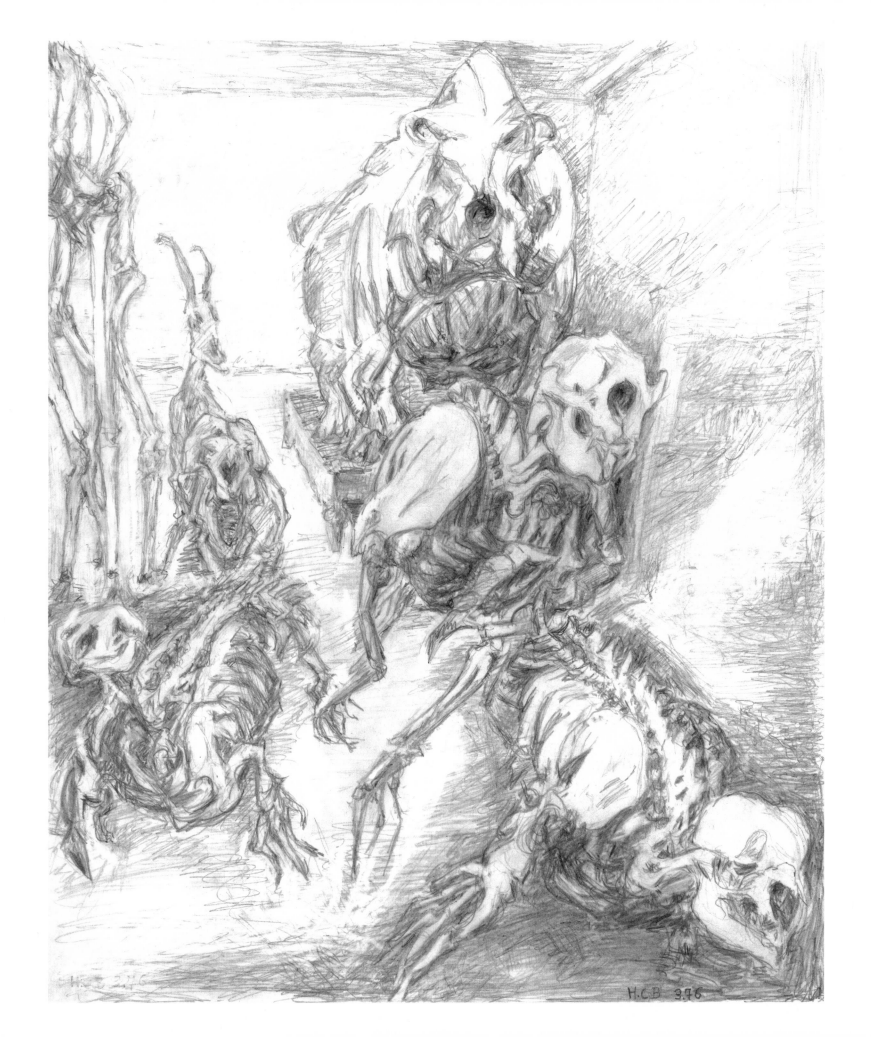

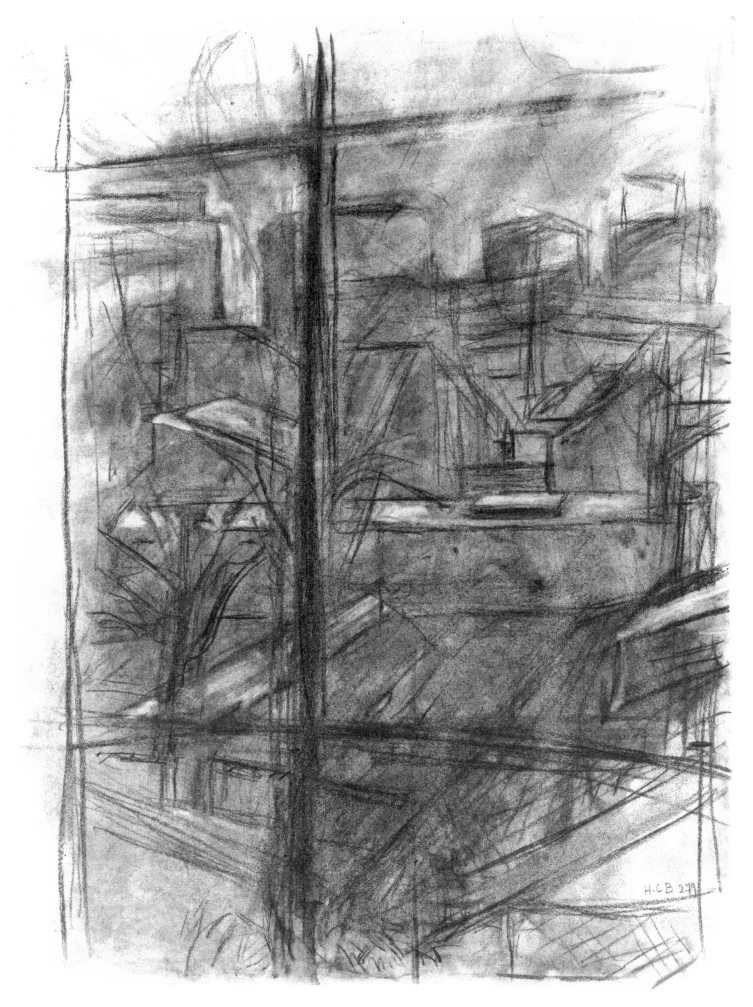

51

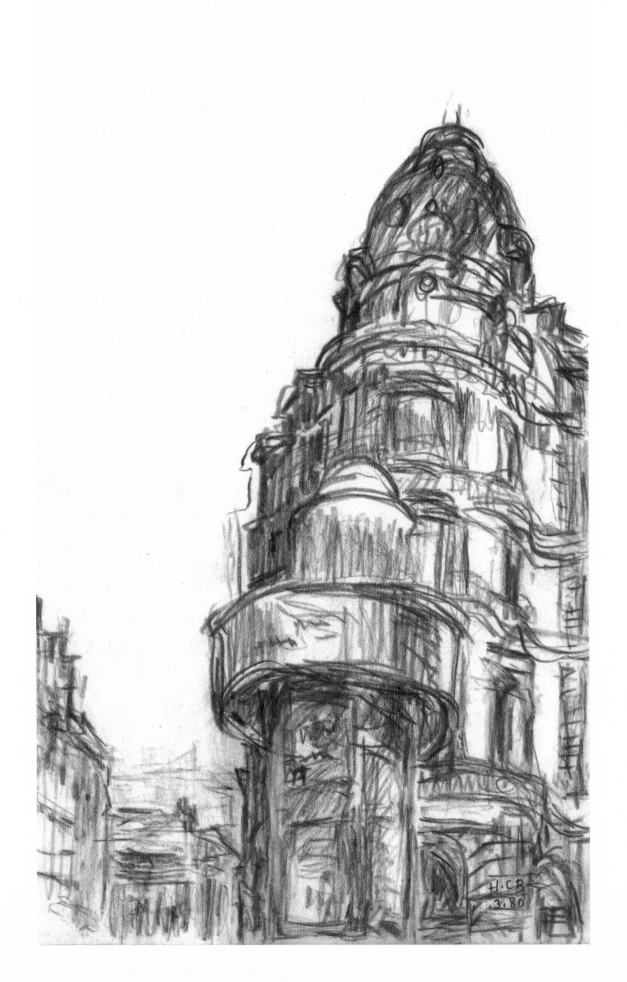

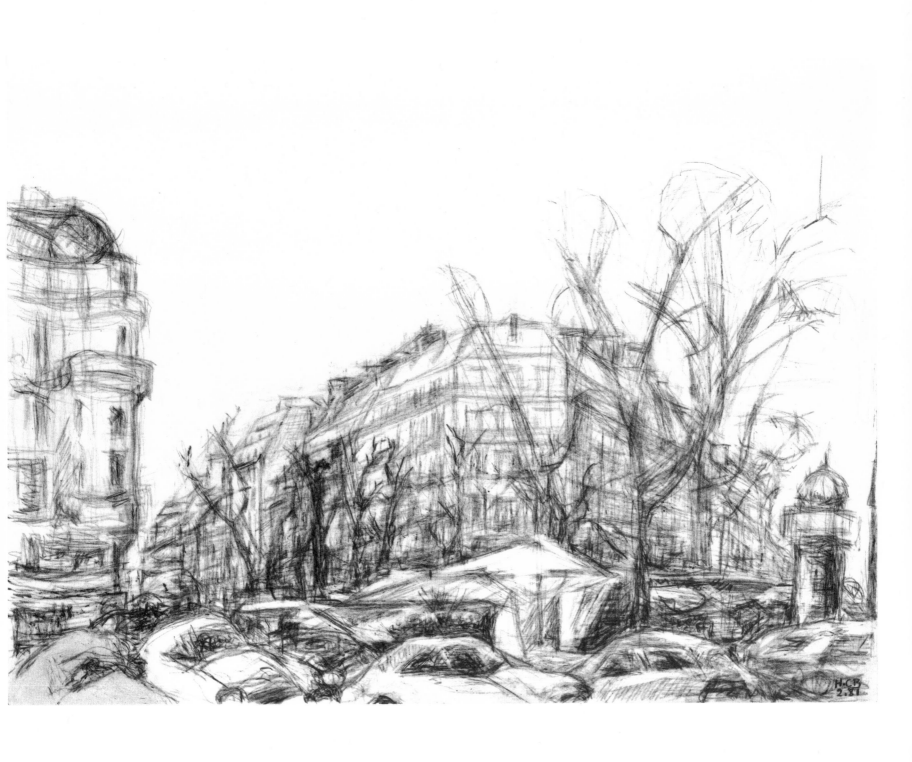

53

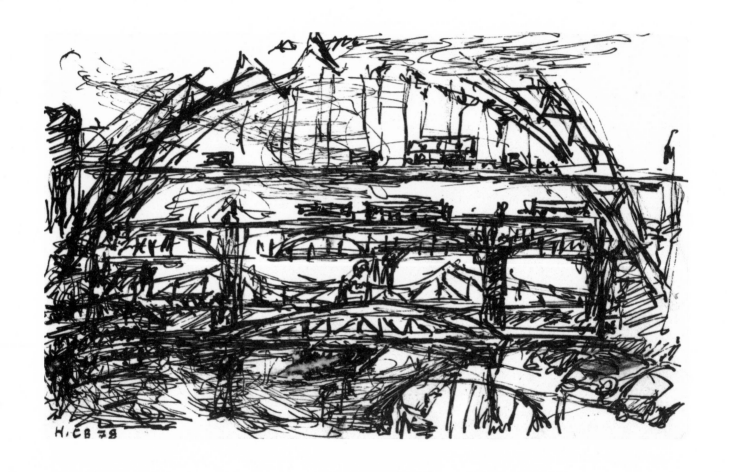

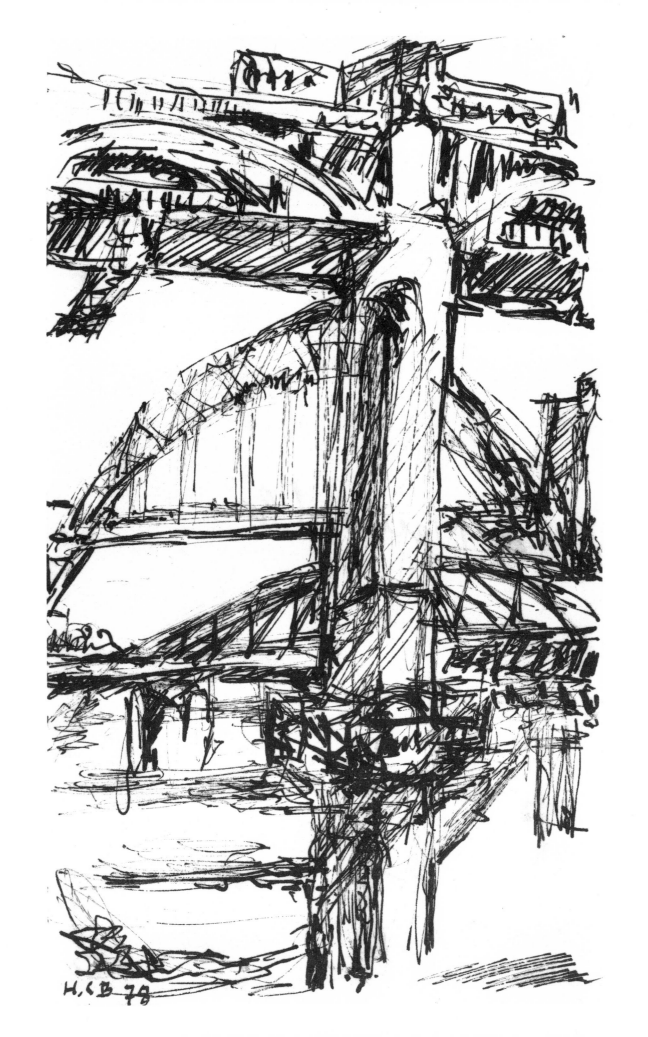

H.CB 78

55

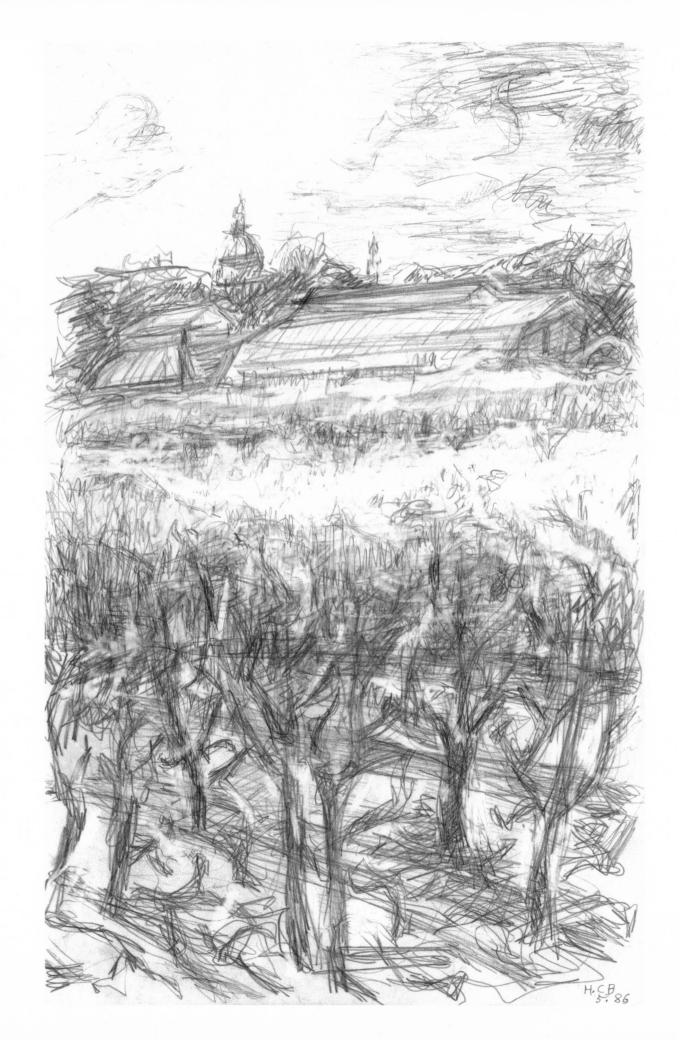

H.C.B
5. 86

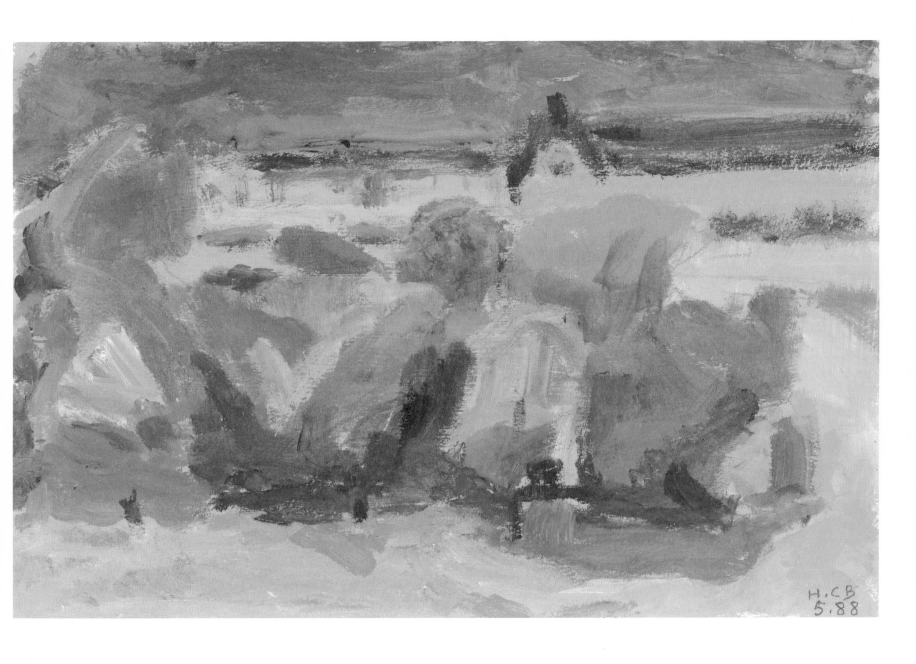

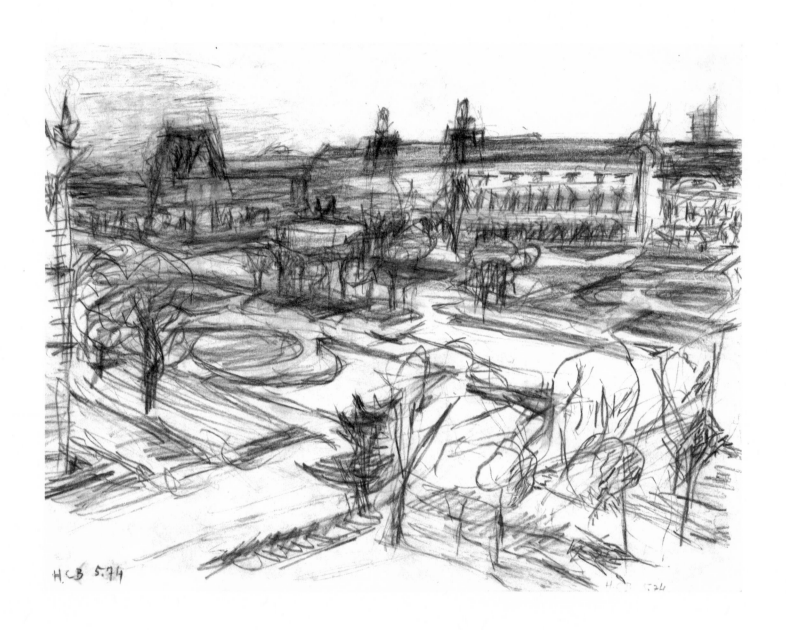

HCB 5.74

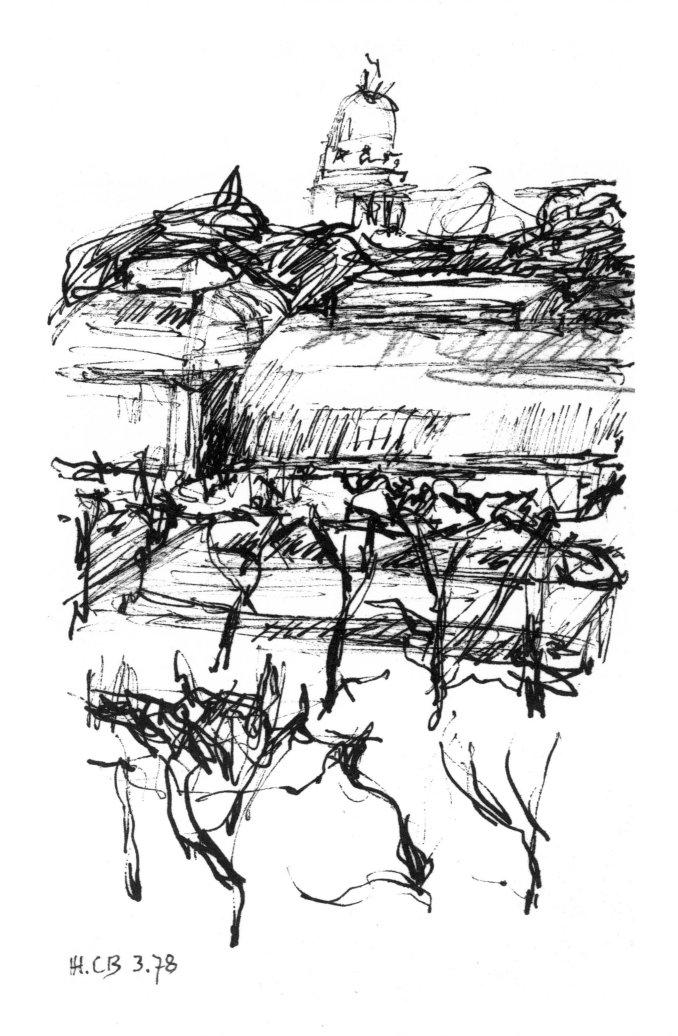

H.CB 3.78

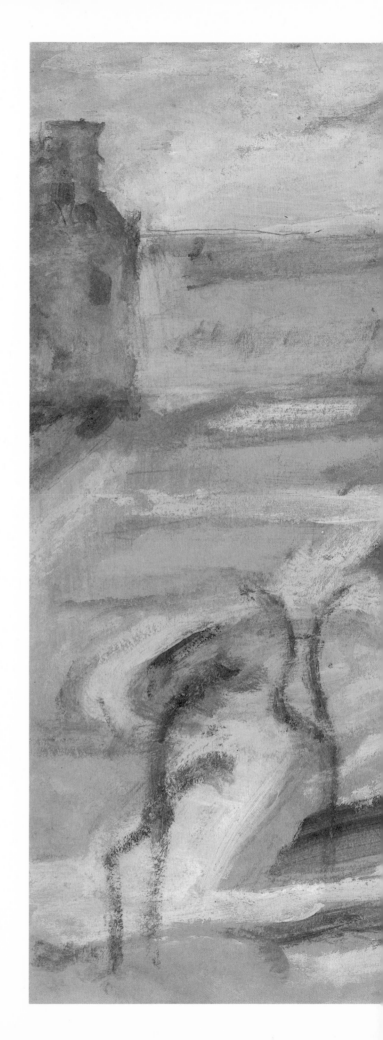

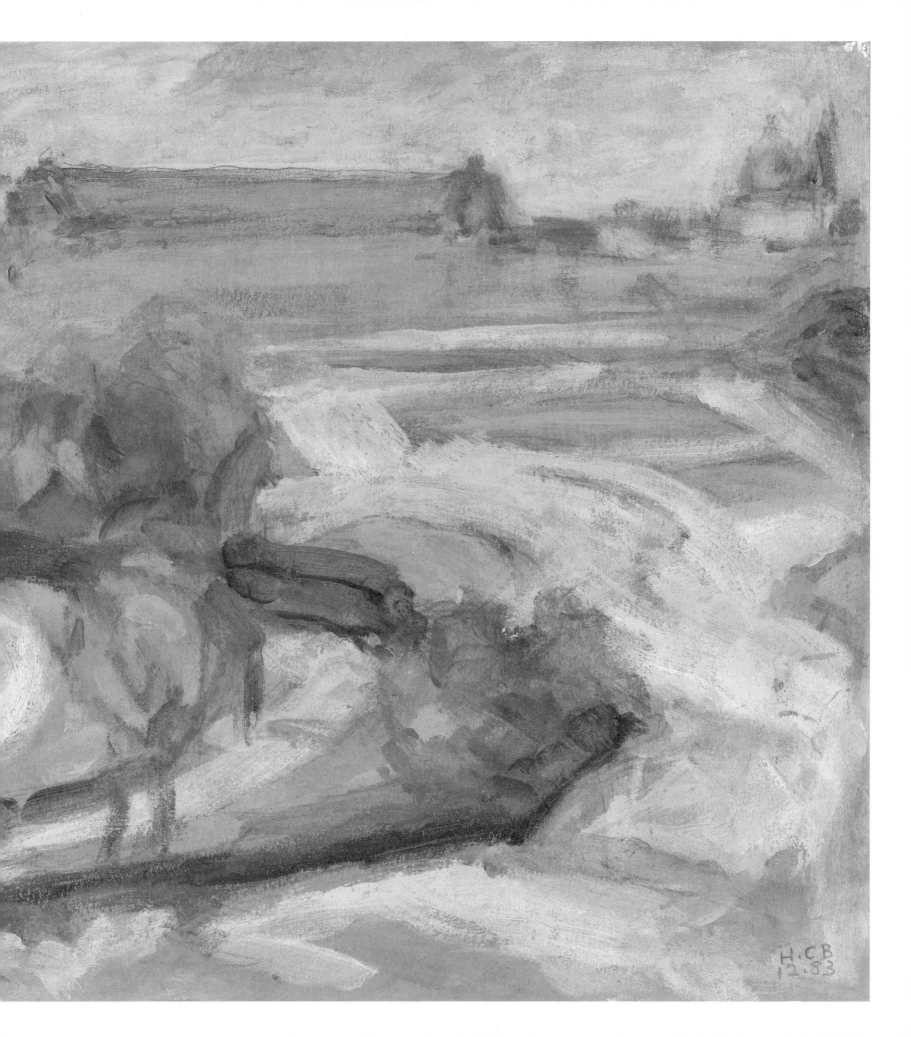

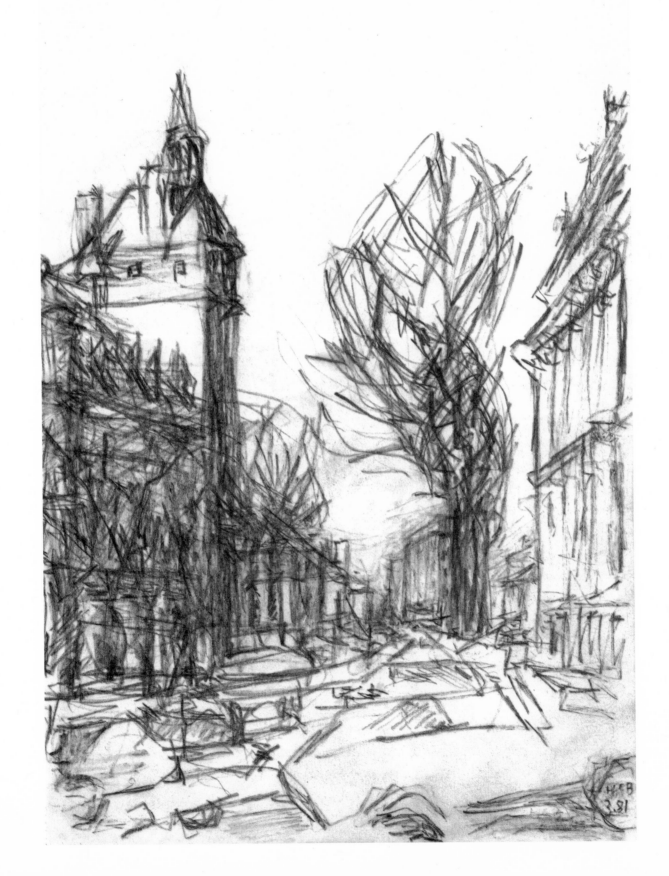

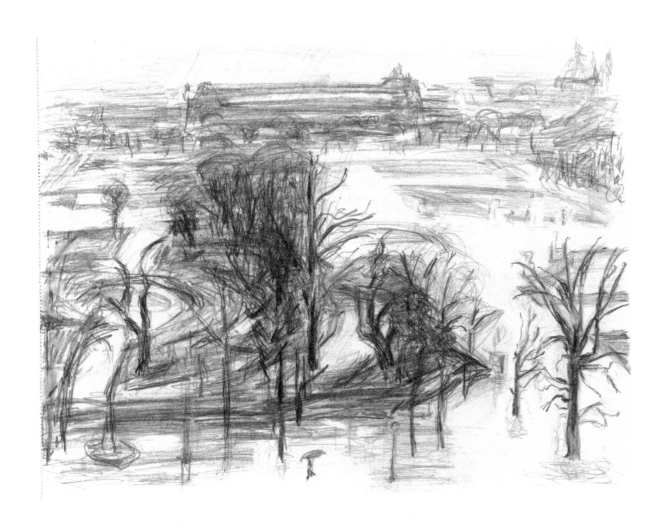

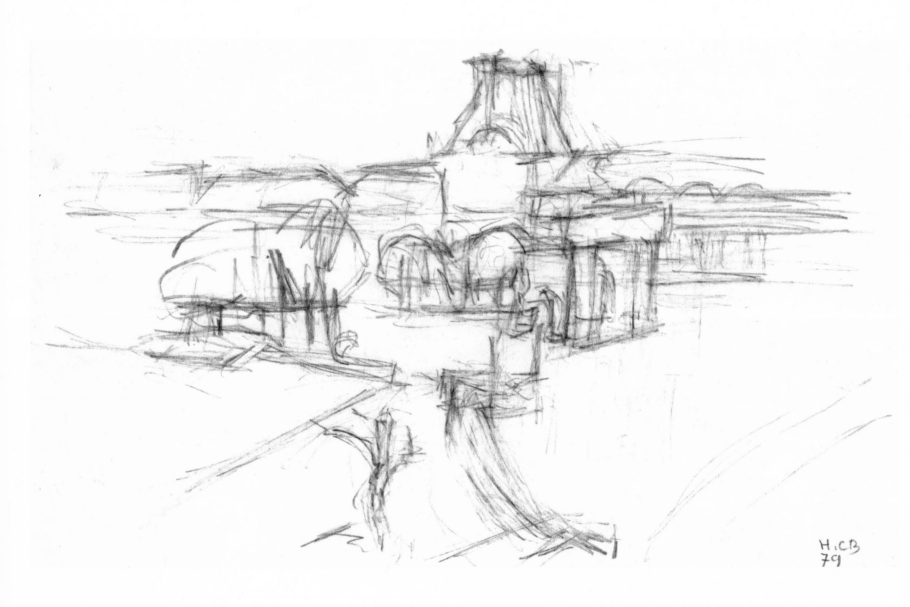

64

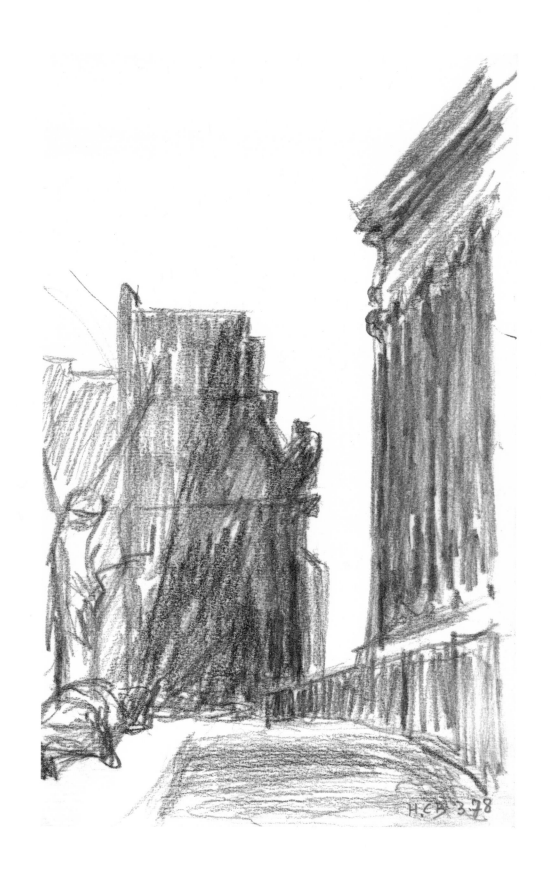

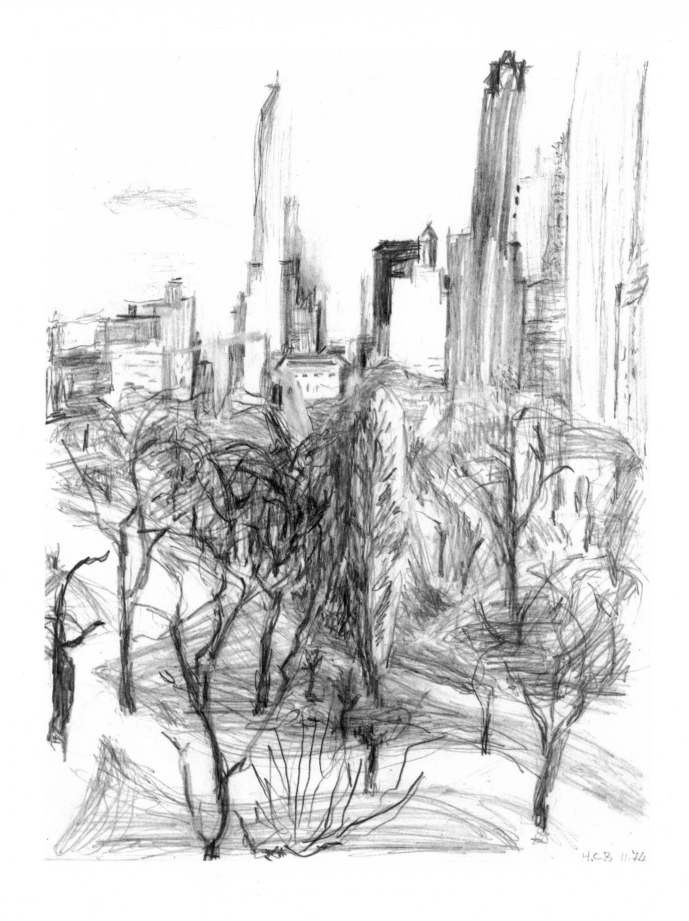

H.C.B 11.74

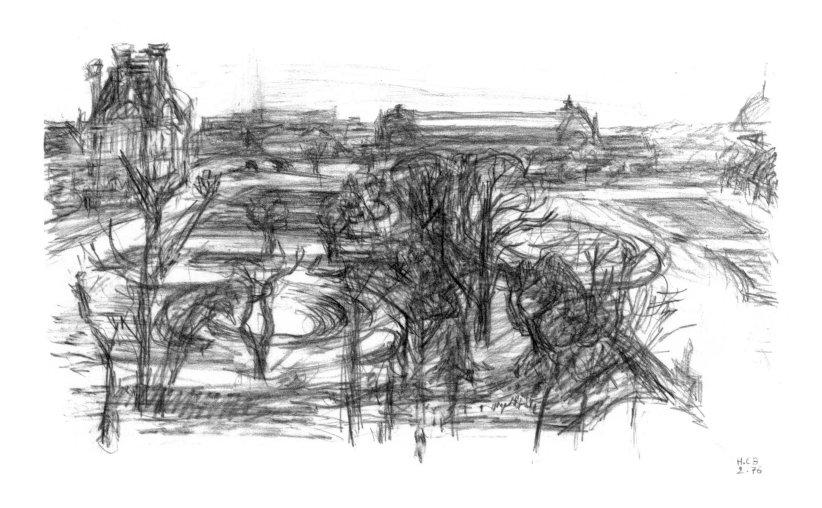

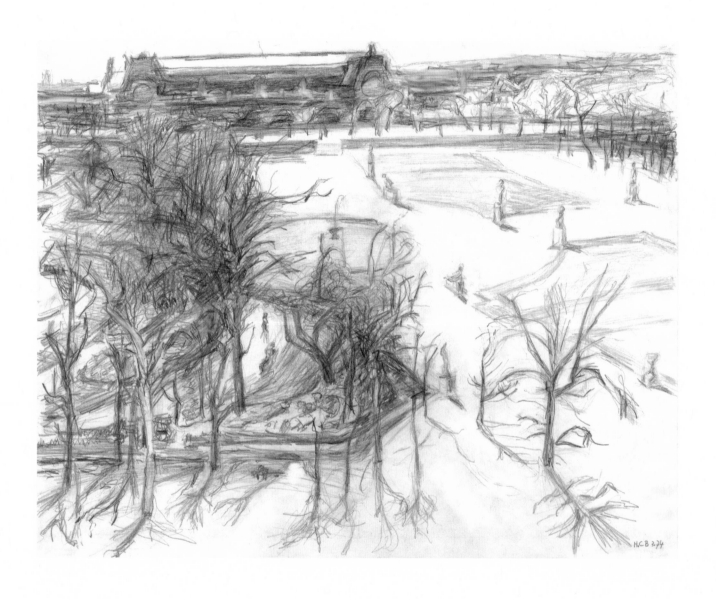

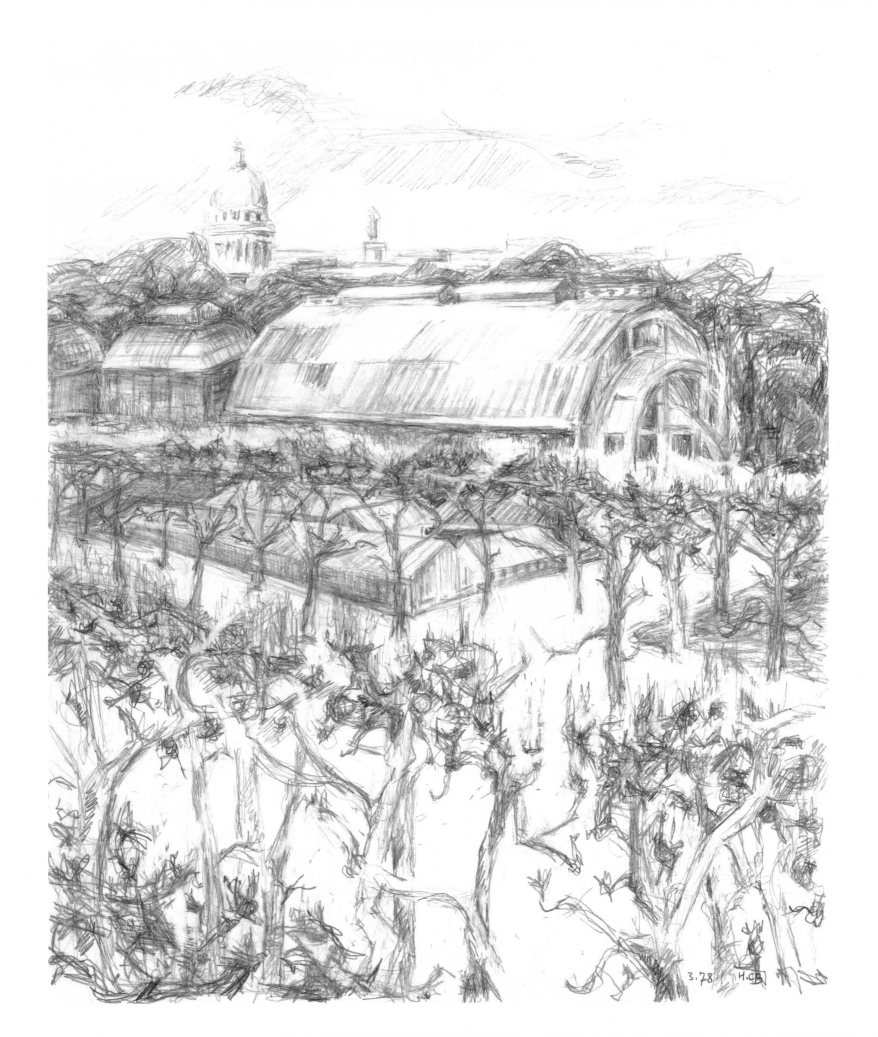

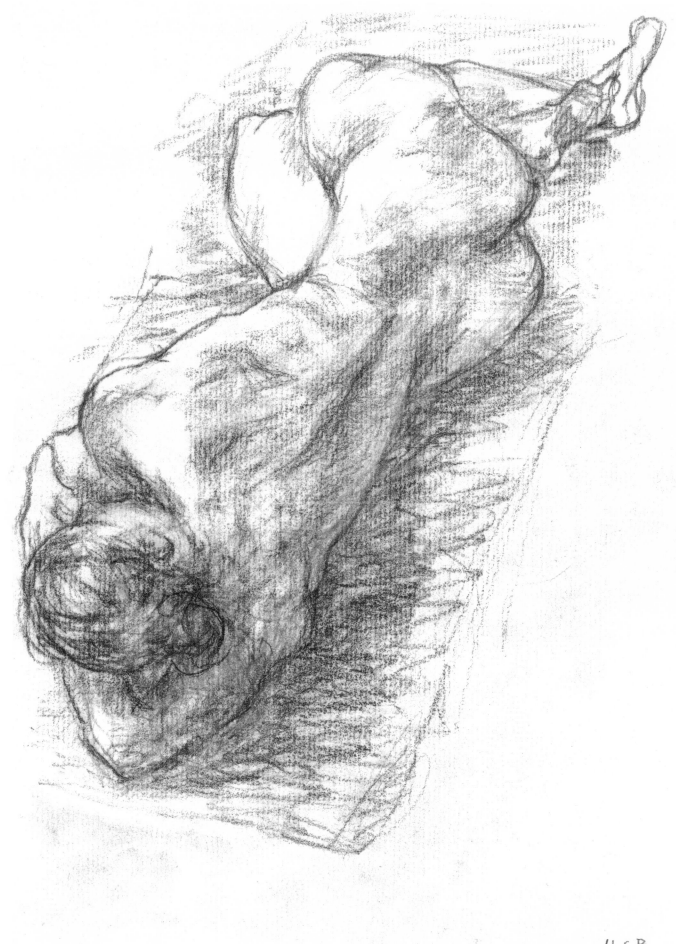

H.CB
4.86

71

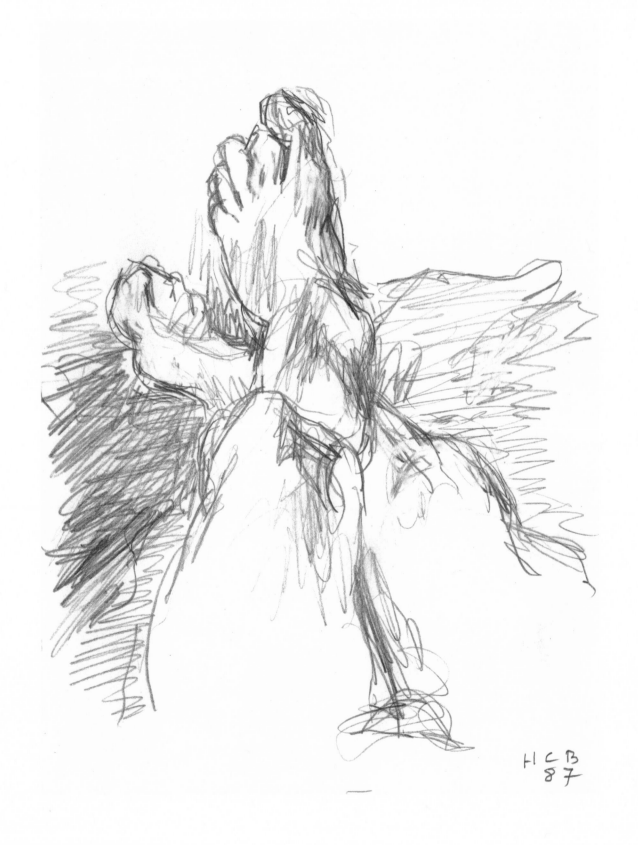

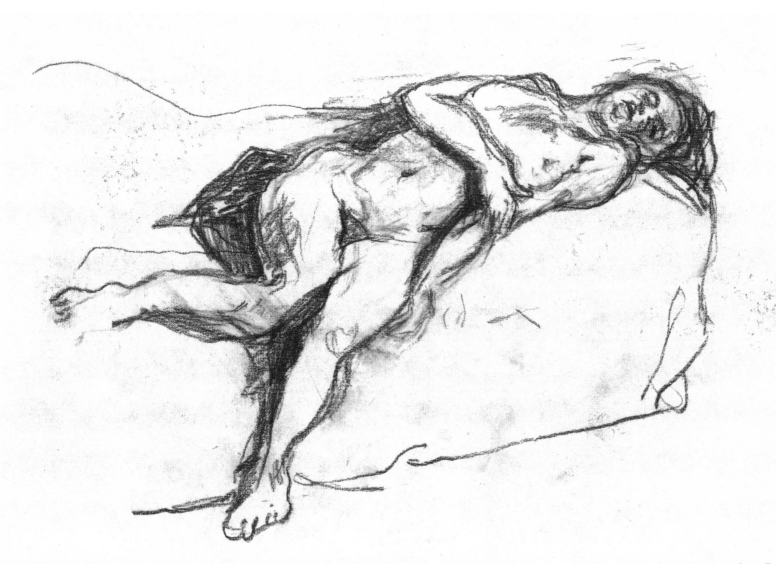

H.CB
10.85

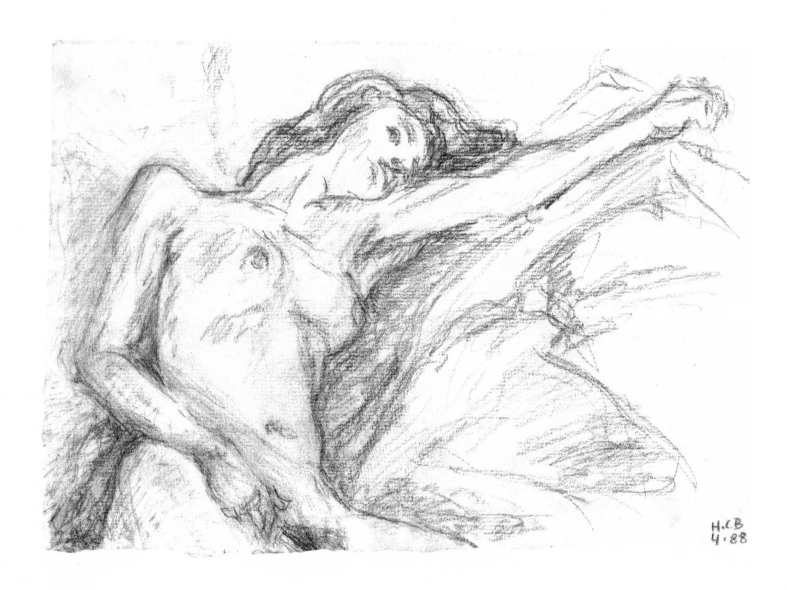

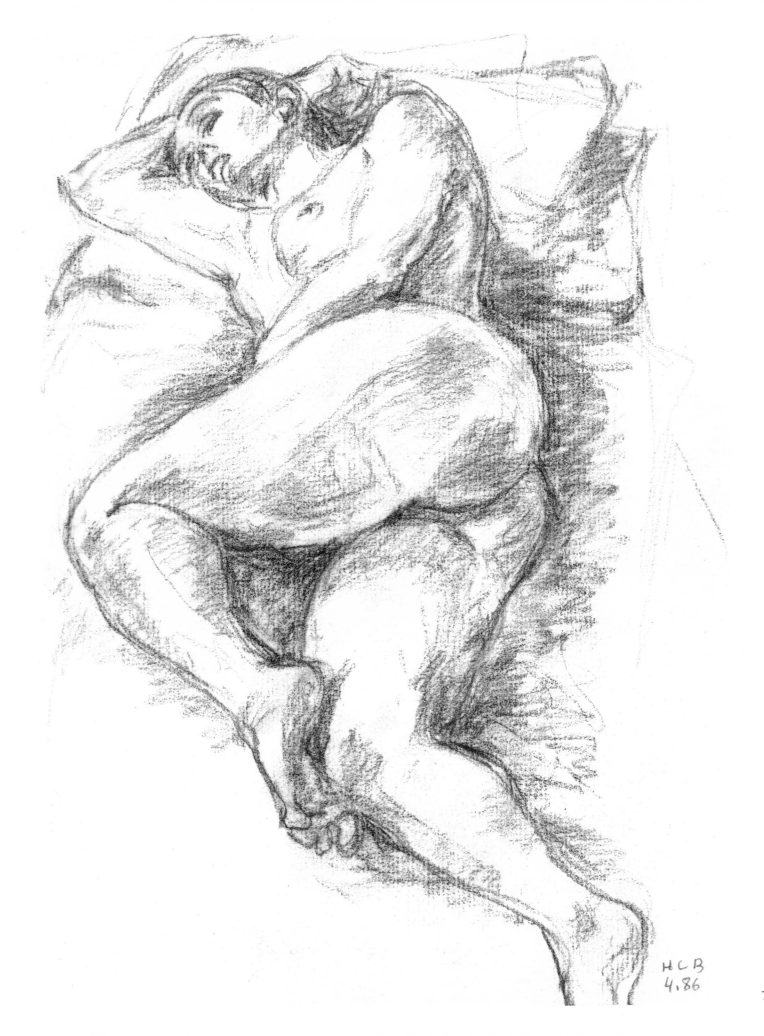

HCB
4.86

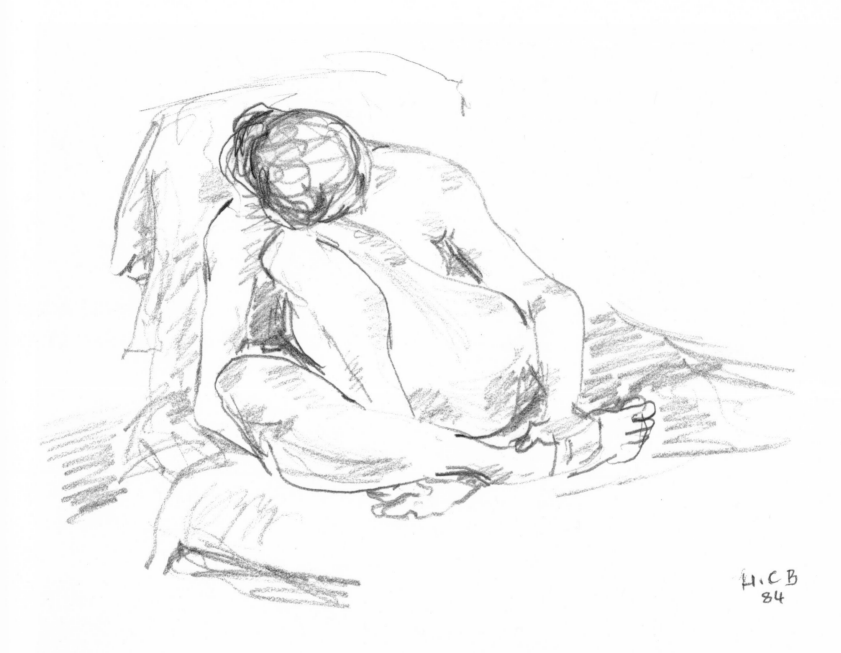

H.C.B
84

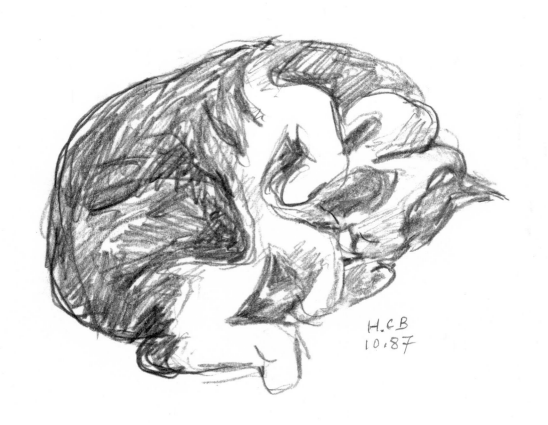

H.CB
10.87

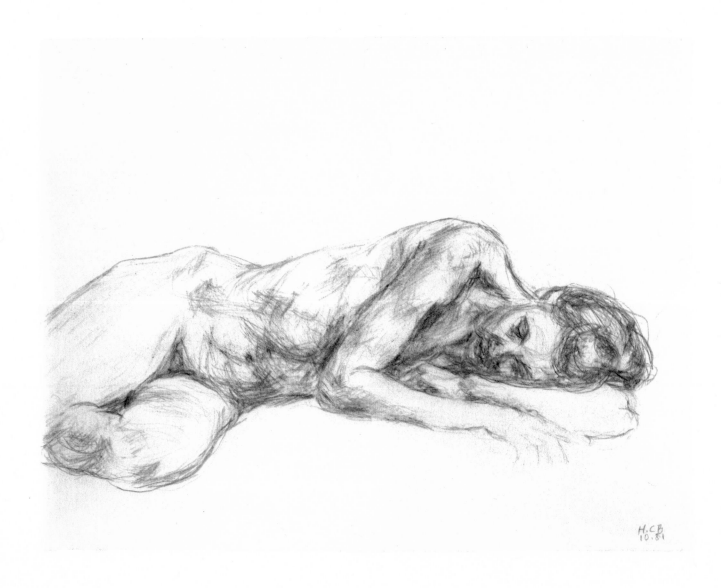

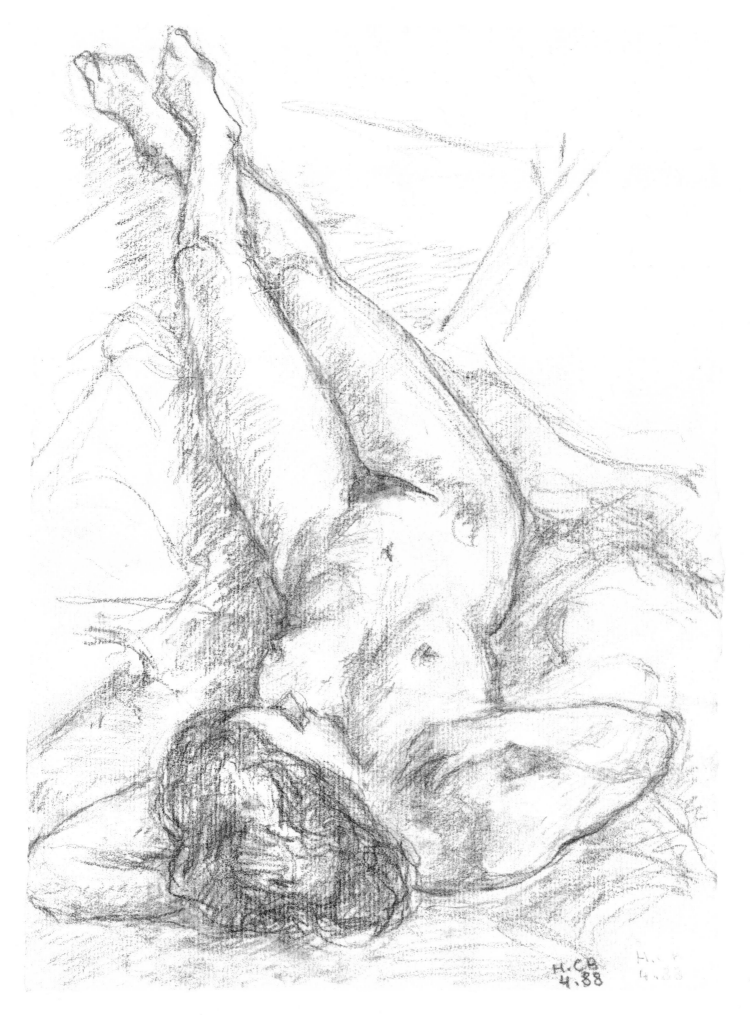

H.C.B.
4.88

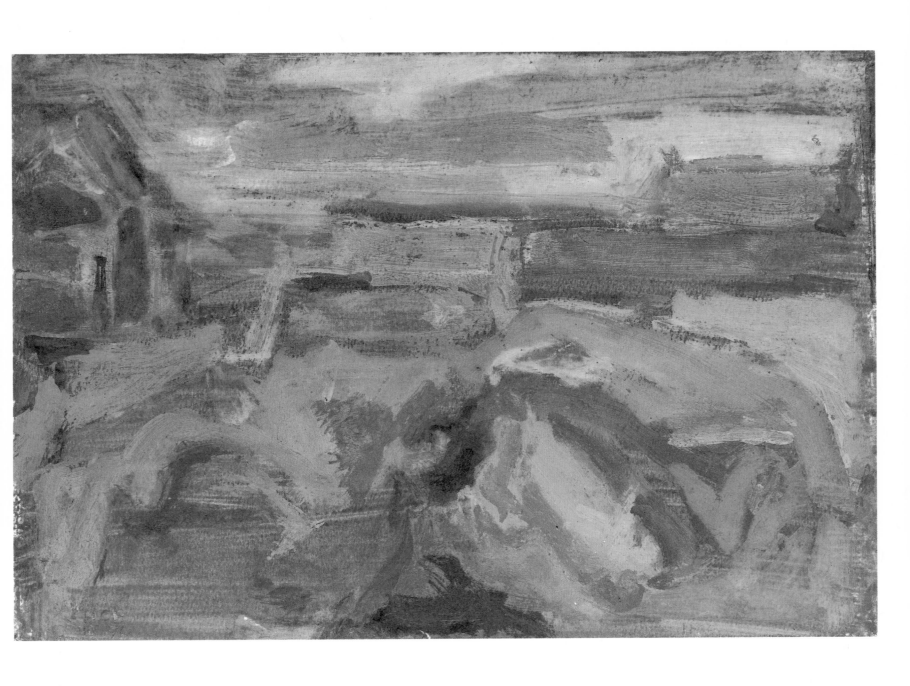

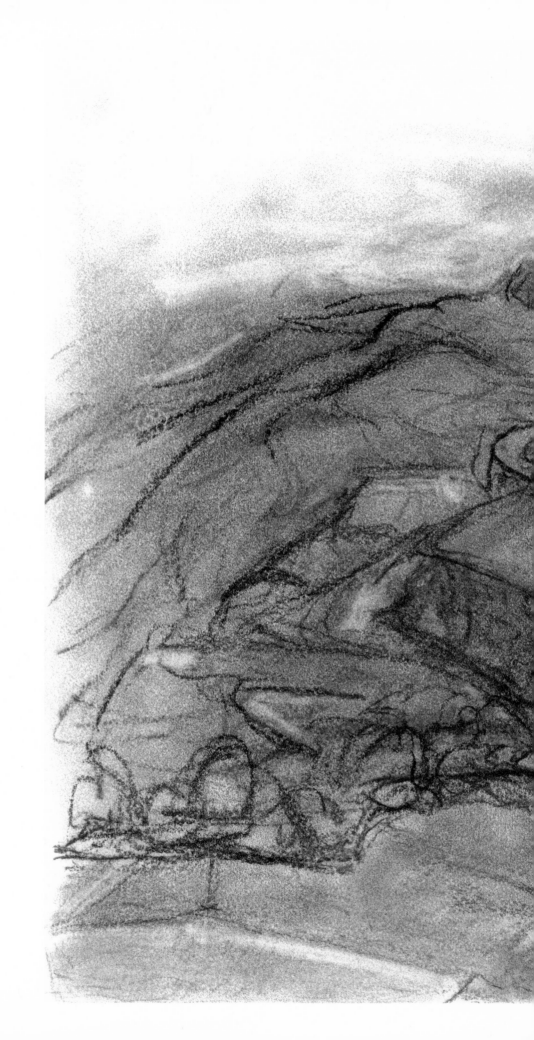

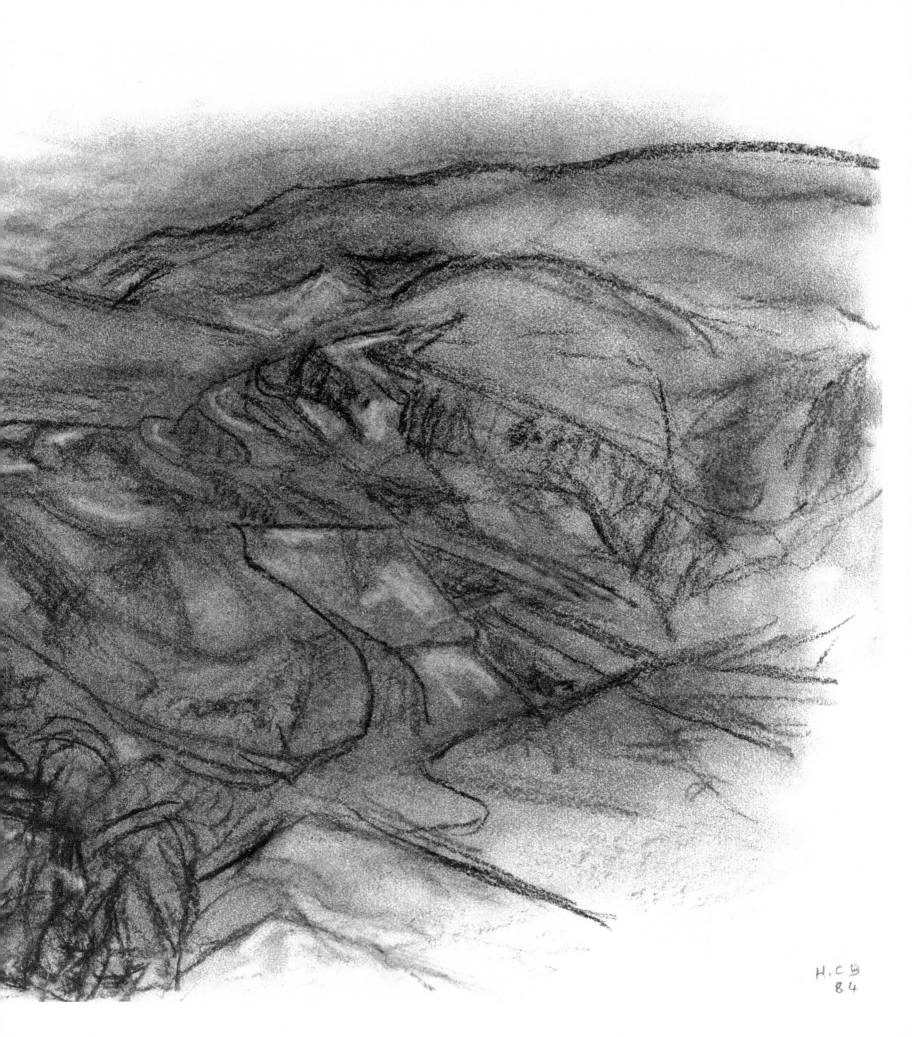

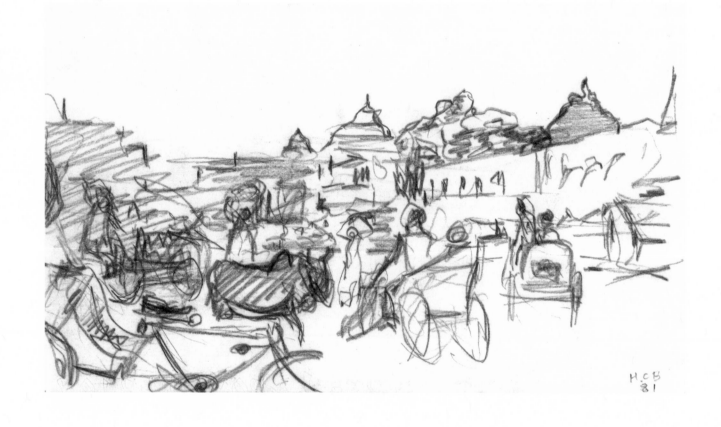

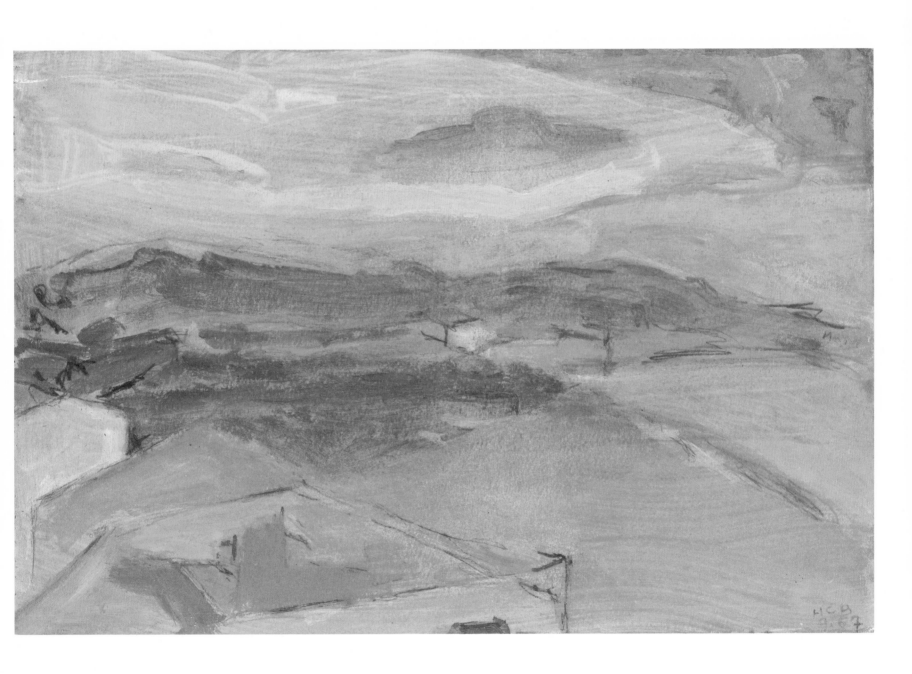

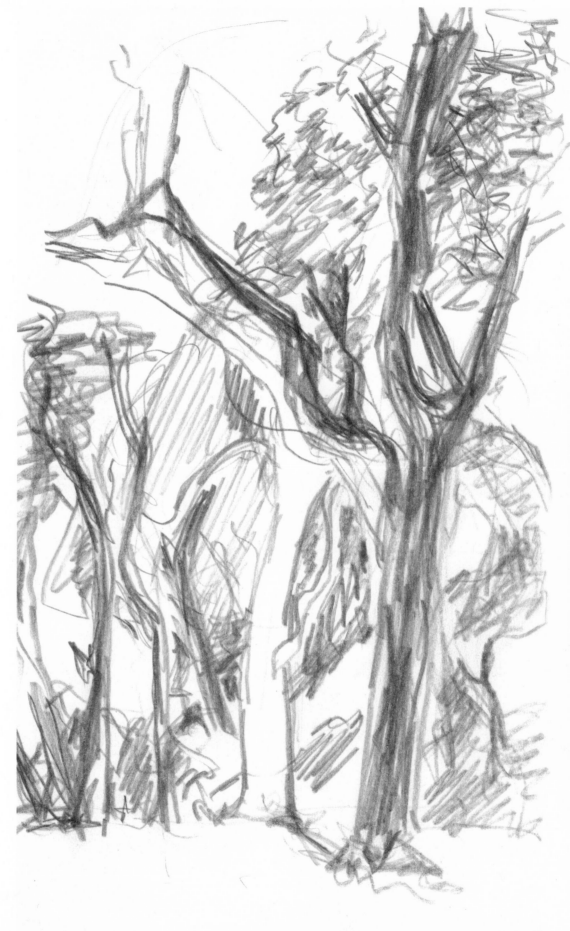

H.C.B
80

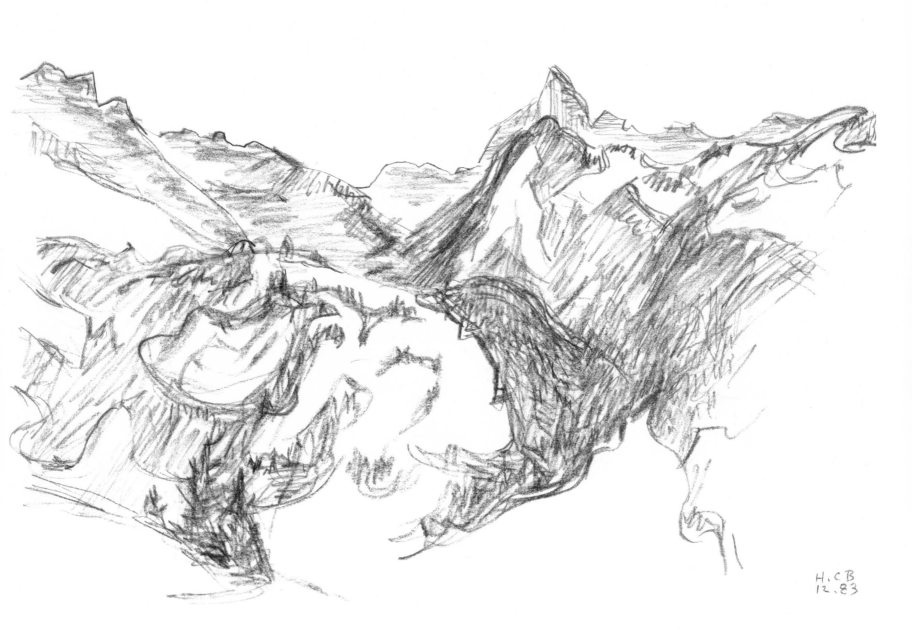

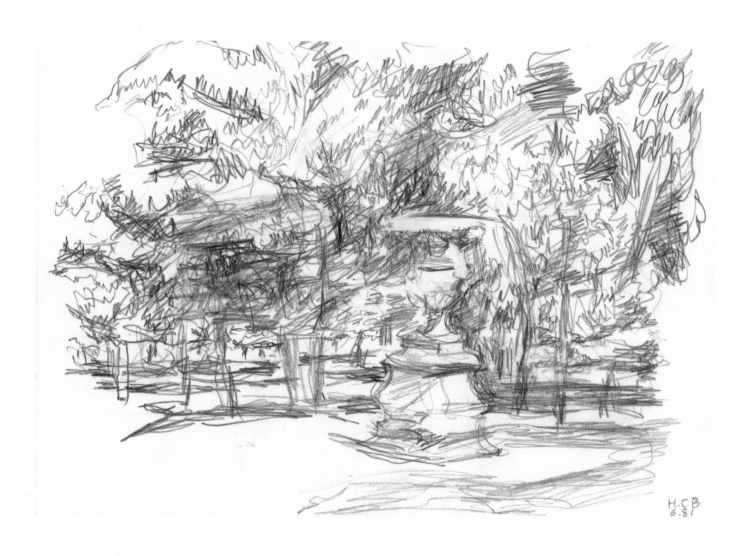

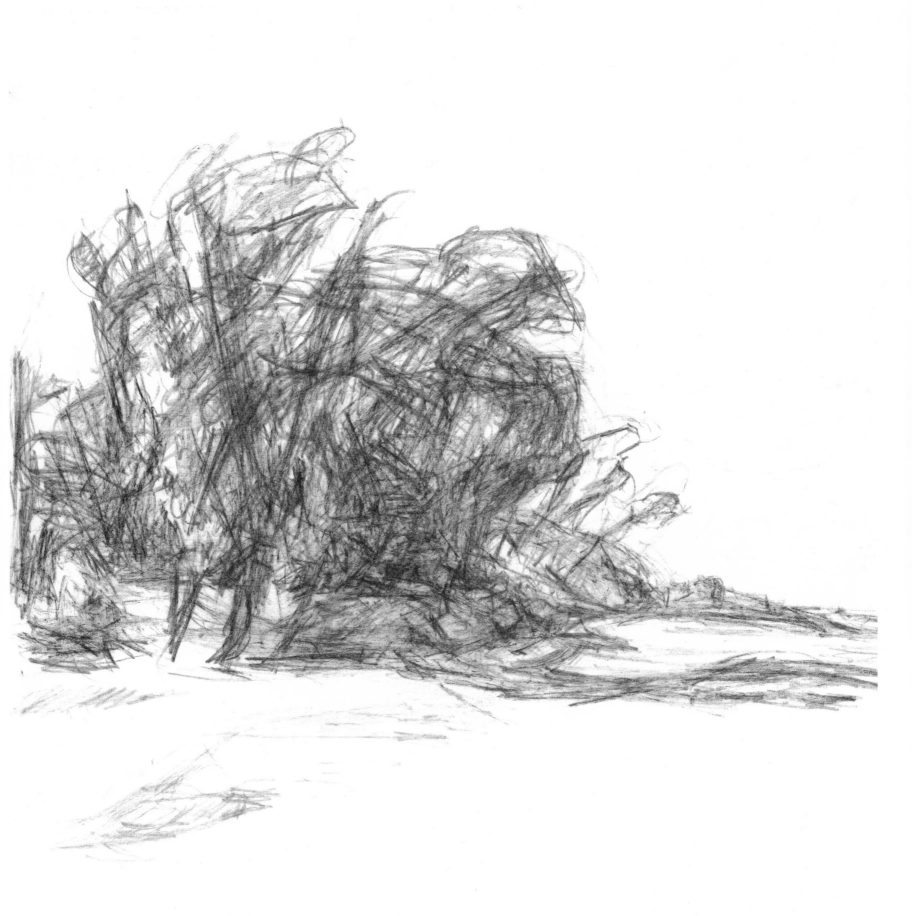

H.CB
3.81

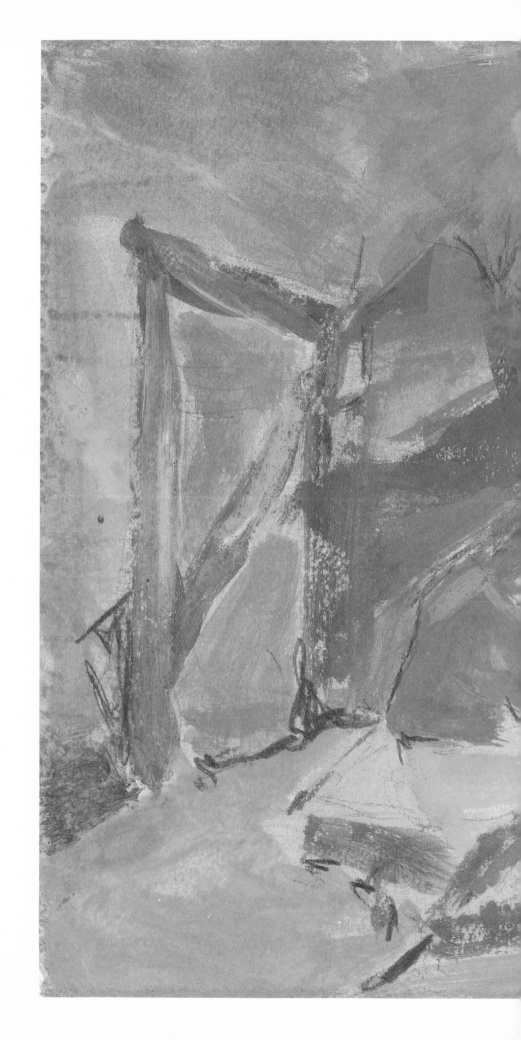

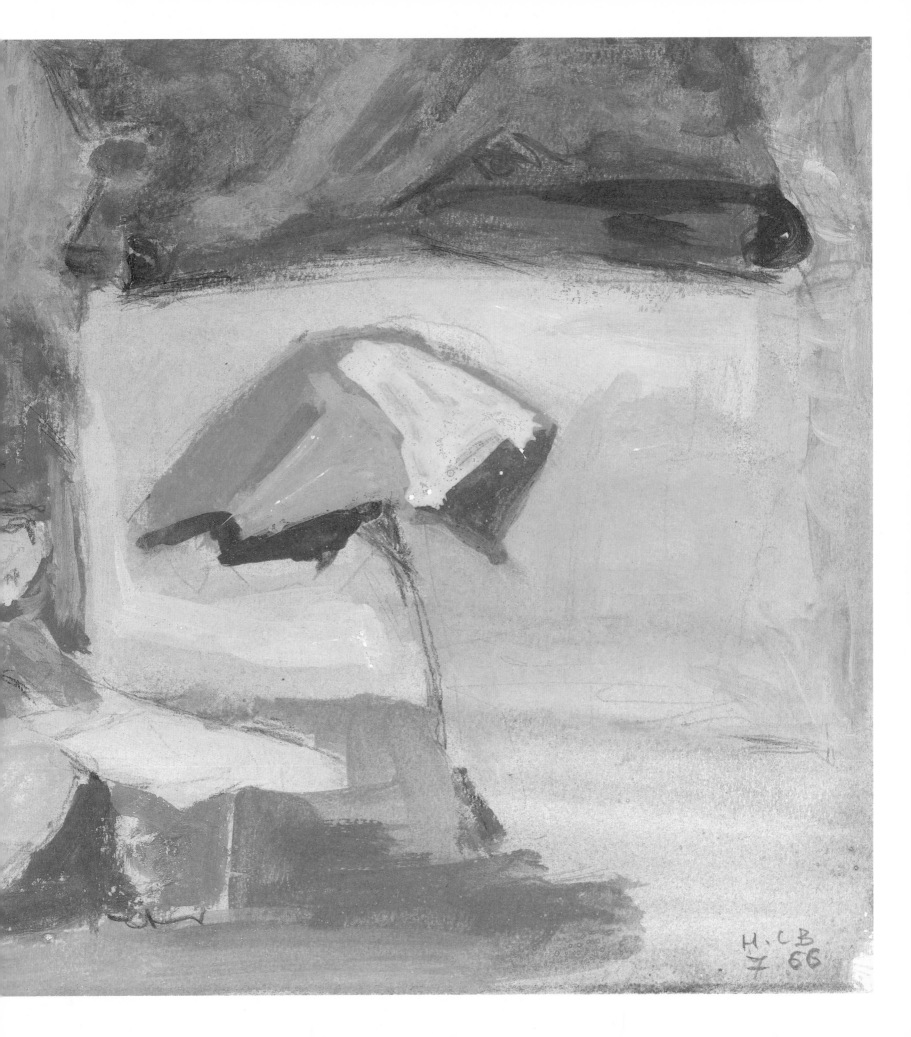

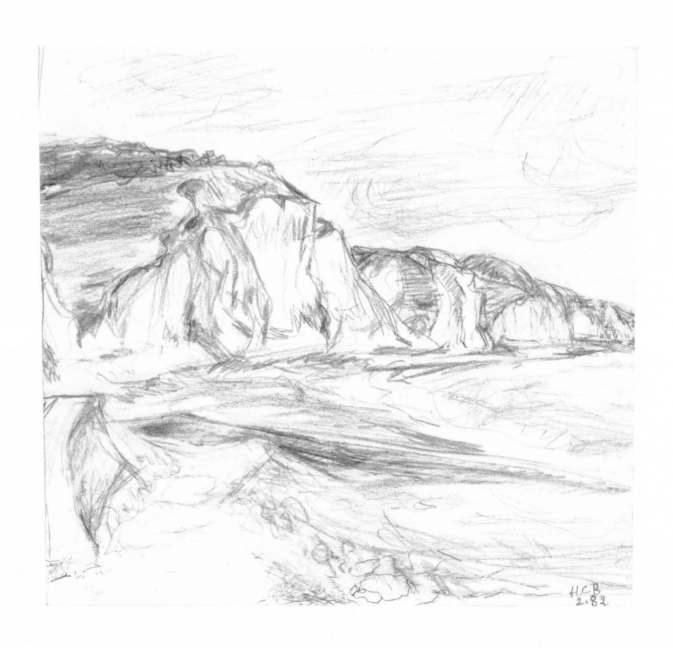

List of Plates

References are to page numbers

57 *Tuileries-Orsay,* May 1988
Tempera
20 x 30 cm (7⅞ x 11¾ in.)

58 *Carrousel,* May 1974
Black chalk
24 x 30.4 cm (9½ x 12 in.)

59 *Jardin des Plantes,* March 1978
Ink
18 x 11.2 cm (7⅛ x 4½ in.)

60 *Orsay,* December 1983
Tempera
24 x 32 cm (9½ x 12⅝ in.)

62 *Conciergerie,* March 1981
Black chalk
24 x 14.8 cm (9½ x 5¾ in.)

63 *Tuileries,* March 1974
Black chalk
23.4 x 31.9 cm (9¼ x 12½ in.)
Private Collection, USA

64 *Carrousel,* 1979
Black chalk
14.8 x 24 cm (5¾ x 9½ in.)

65 *Madeleine,* March 1978
Black chalk
18 x 11.3 cm (7⅛ x 4½ in.)

66 *New York,* November 1974
Black chalk
22.7 x 17 cm (8⅞ x 6¾ in.)

67 *Tuileries,* February 1976
Black chalk
22.5 x 35.5 cm (8⅞ x 14 in.)

68 *Tuileries,* March 1974
Black chalk
39 x 48 cm (15⅜ x 18⅞ in.)

69 *Jardin des Plantes,* March 1978
Black chalk
48.3 x 39.2 cm (19 x 15½ in.)

71 *B.,* April 1986
Black chalk
29.5 x 21 cm (11½ x 8¼ in.)

72 *H. C.-B.,* 1987
Black chalk
21 x 14.8 cm (8¼ x 5¾ in.)

73 *B.,* October 1985
Black chalk
29 x 42.7 cm (11⅜ x 16¾ in.)

74 *A.,* April 1988
Black chalk
21 x 29.5 cm (8¼ x 11½ in.)

75 *C.,* April 1986
Black chalk
29 x 20.5 cm (11⅜ x 8 in.)

76 *B.,* 1984
Black chalk
20.6 x 29.7 cm (8 x 11⅝ in.)

77 *Ulysses,* October 1987
Black chalk
14.8 x 20.4 cm (5¾ x 8 in.)

78 *G.,* October 1981
Black chalk
25 x 32 cm (9⅞ x 12⅝ in.)
Mrs S. Blumenfeld Collection,
San Francisco

79 *A.,* April 1988
Black chalk
29 x 20.5 cm (11⅜ x 8 in.)

81 *Tuileries,* October 1970
Tempera
18 x 26.5 cm (7⅛ x 10½ in.)

82 *Oppedette,* 1984
Charcoal
39 x 57.8 cm (15⅜ x 22¾ in.)

84 *Puri, India,* 1981
Black chalk
14.8 x 24 cm (5¾ x 9½ in.)

85 *Cannes,* July 1967
Tempera
18 x 25.5 cm (7⅛ x 10 in.)

86 *Trees,* 1980
Black chalk
21.5 x 12.5 cm (8½ x 5 in.)

87 *Switzerland,* December 1983
Black chalk
17.3 x 24.3 cm (6⅞ x 9½ in.)

88 *Tuileries,* June 1981
Black chalk
17.3 x 24.4 cm (6⅞ x 9½ in.)

89 *Loire,* March 1981
Black chalk
23.7 x 22 cm (9⅜ x 8⅝ in.)

90 *The Painter Varlin,* July 1966
Tempera
18 x 26.5 cm (7⅛ x 10½ in.)

92 *Dieppe,* February 1982
Pencil
15.8 x 16.5 cm (6⅛ x 6½ in.)

96 *Orissa, India,* 1981
Ink
17.3 x 24.4 cm (6⅞ x 9½ in.)

On the jacket:
Vachères, November 1987
Ink
17.3 x 24.4 cm (6⅞ x 9½ in.)

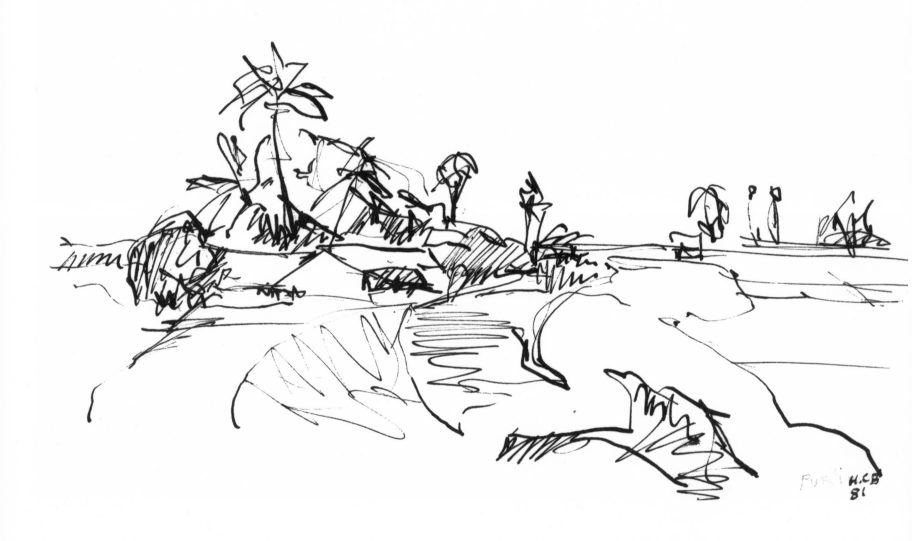

Exhibitions

February 1975	Carlton Gallery, New York. Catalogue preface by Julian Levy
December 1975	Galerie Bischofsberger, Zurich. Catalogue preface by Manuel Gasser
July 1976	Galerie Lucien Henry, Forcalquier
May 1981	Musée National d'Art Moderne, Paris. Catalogue prefaces by James Lord and André Berne Joffroy
February 1982	Museo de Arte Moderno, Mexico
March 1983	French Institute, Stockholm
September 1983	Galleria d'Arte Moderna e Padiglione d'Arte Contemporanea, Milan. Catalogue prefaces by Lamberto Vitali and Giuliana Scimé
November 1983	Tor Vergata University, Rome
June 1984	Museum of Modern Art, Oxford. Catalogue preface by David Elliott
February 1985	Salzburger Landessammlung, Rupertinum. Catalogue preface by Dieter Schrage
April 1985	Museum moderner Kunst, Palais Liechtenstein, Vienna
June 1985	Galerie Annasäule, Innsbruck
October 1985	French Institute, Athens. Catalogue preface by Michel Brenson
August 1986	Mannheimer Kunstverein. Catalogue prefaces by Roland Scotti, Thomas Schirmböck and Friedrich W. Kasten
September 1987	Arnold Herstand Gallery, New York
March 1989	Ecole des Beaux-Arts, Paris

Acknowledgments

I would like to express my profound gratitude – and that in
alphabetical order – to all those who have been kind enough
to help in the realization of this book:
Marie-Claire Anthonioz, Martine Cartier-Bresson, Louis Deledicq,
Robert Delpire, Georg Eisler, Jean Genoud, Arnold Herstand,
Dan Hofstadter, Colette de Sadeleer, Sam Szafran, Jean-Max Toubeau
and the team of Ideodis-Création.

H. C.-B.